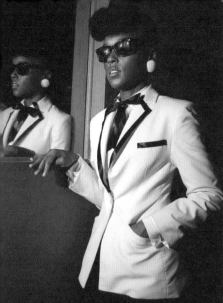
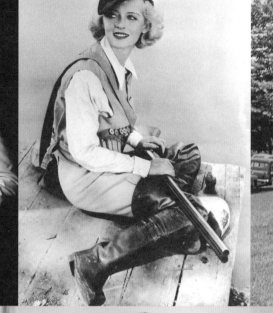
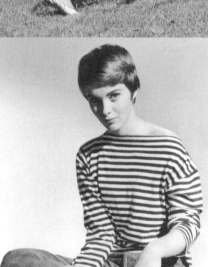
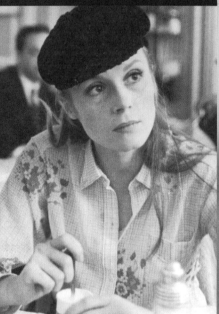
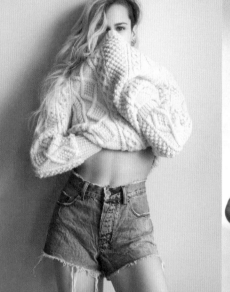

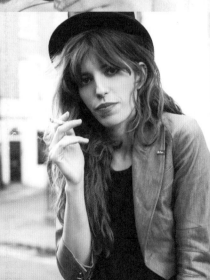
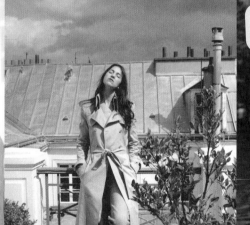

tomboy style

beyond the boundaries of fashion

Lizzie
Garrett Mettler

RIZZOLI
NEW YORK

New York · Paris · London · Milan

dedication

For MSM

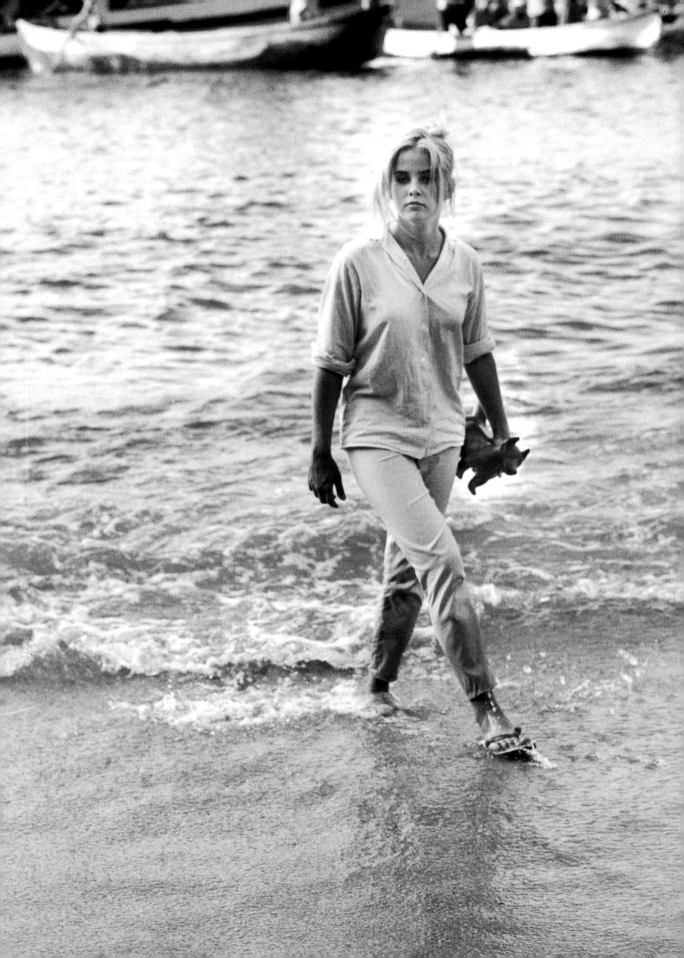

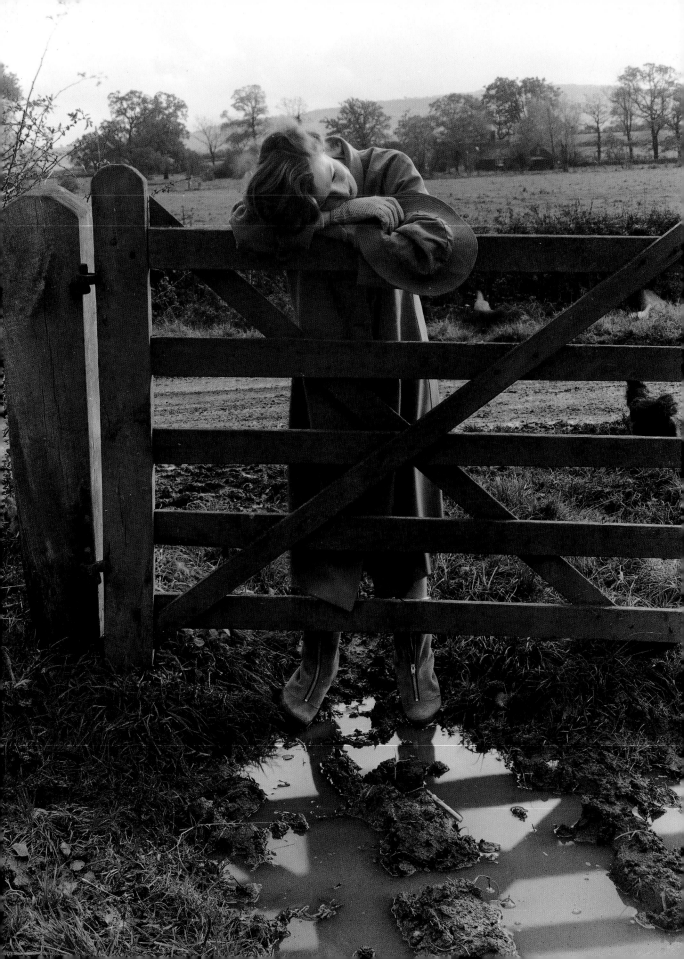

Contents

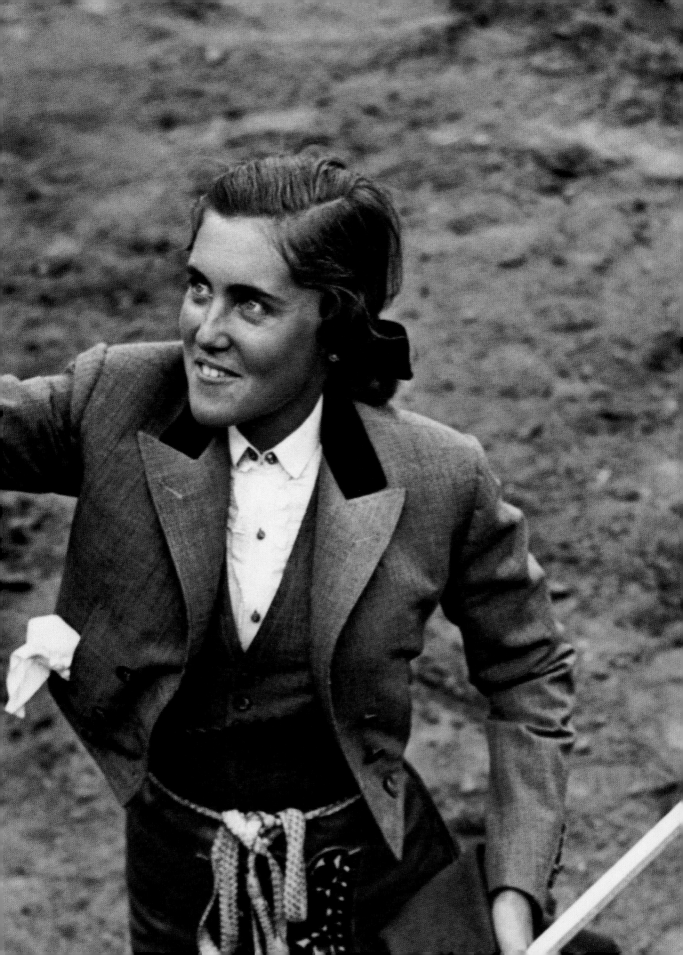

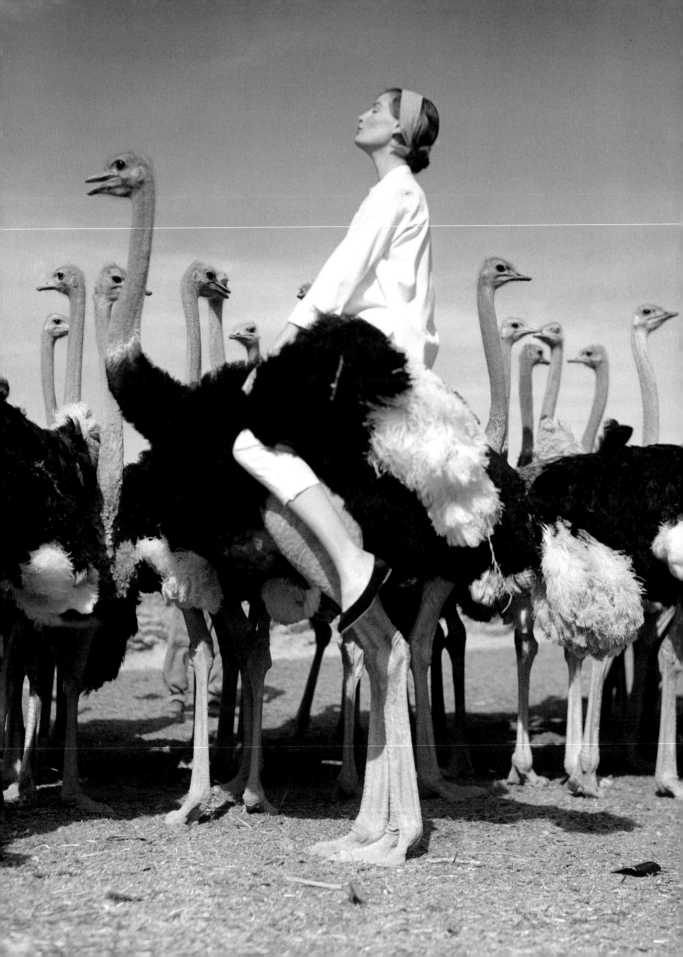

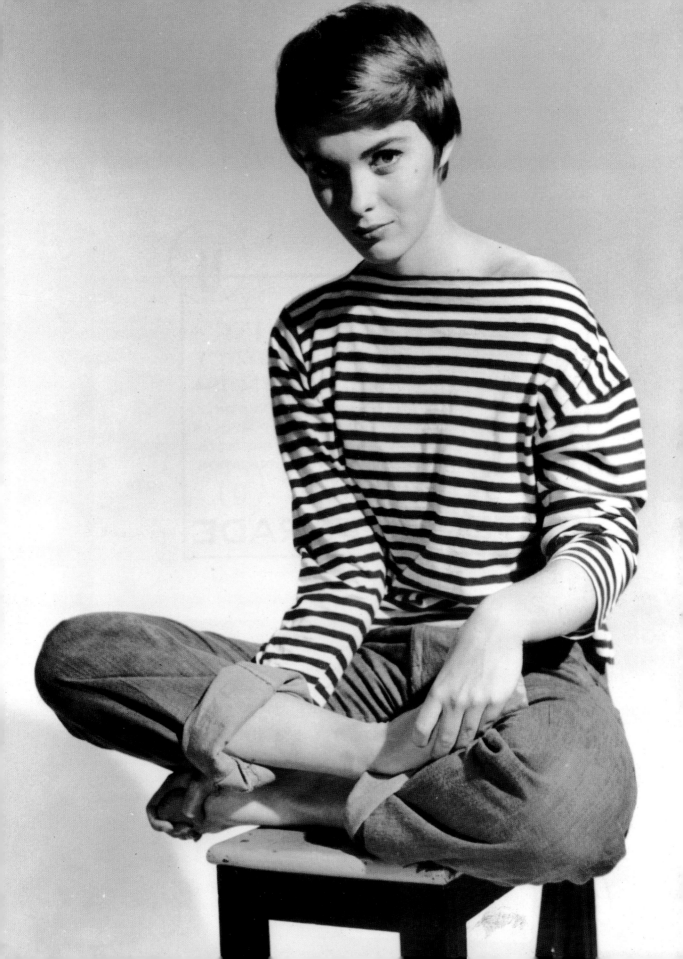

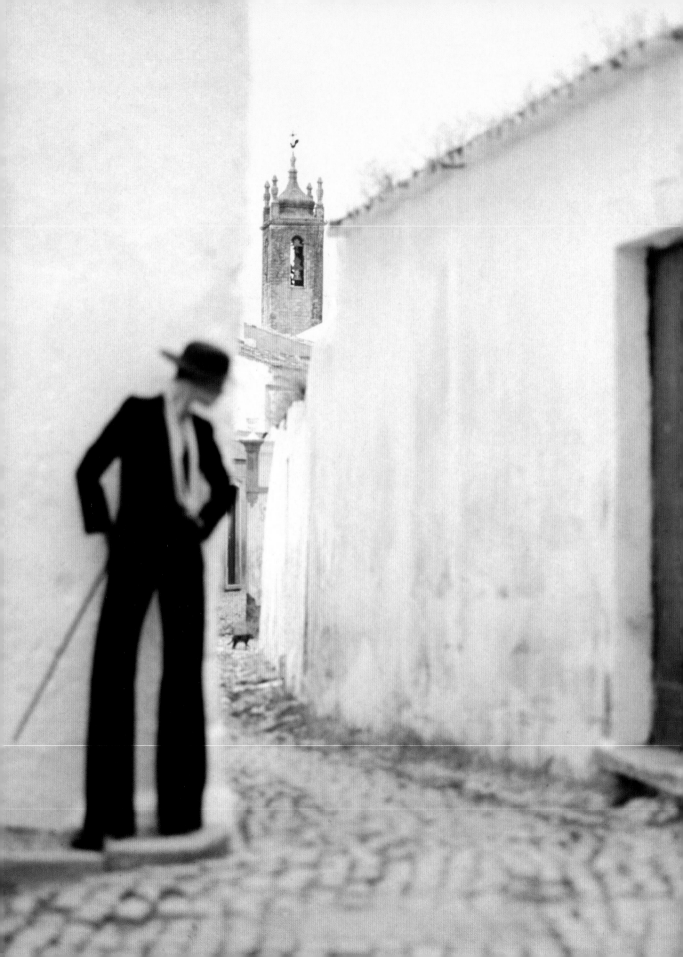

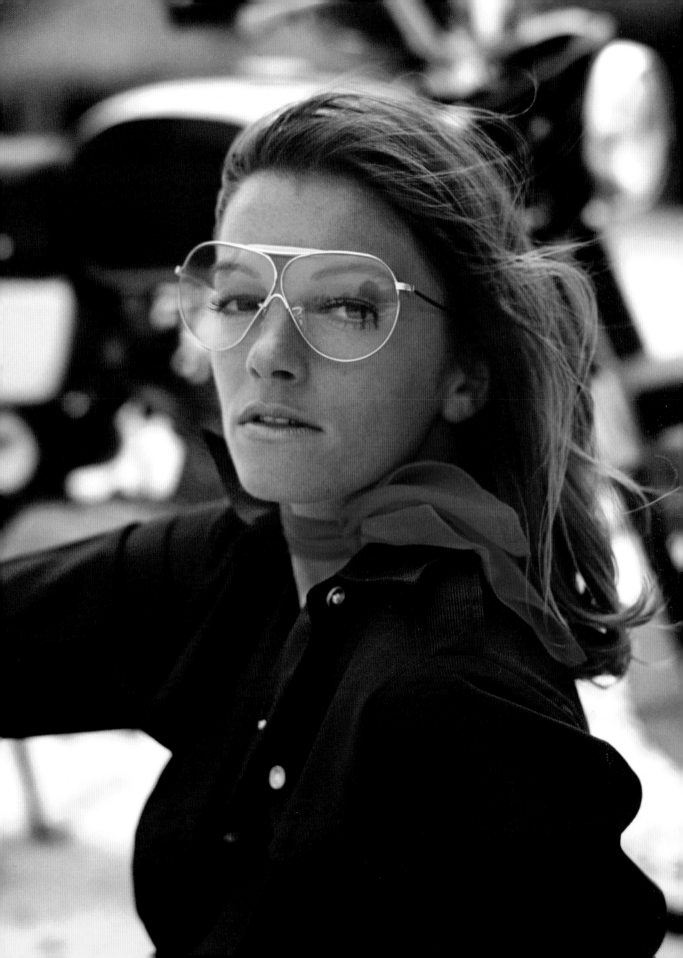

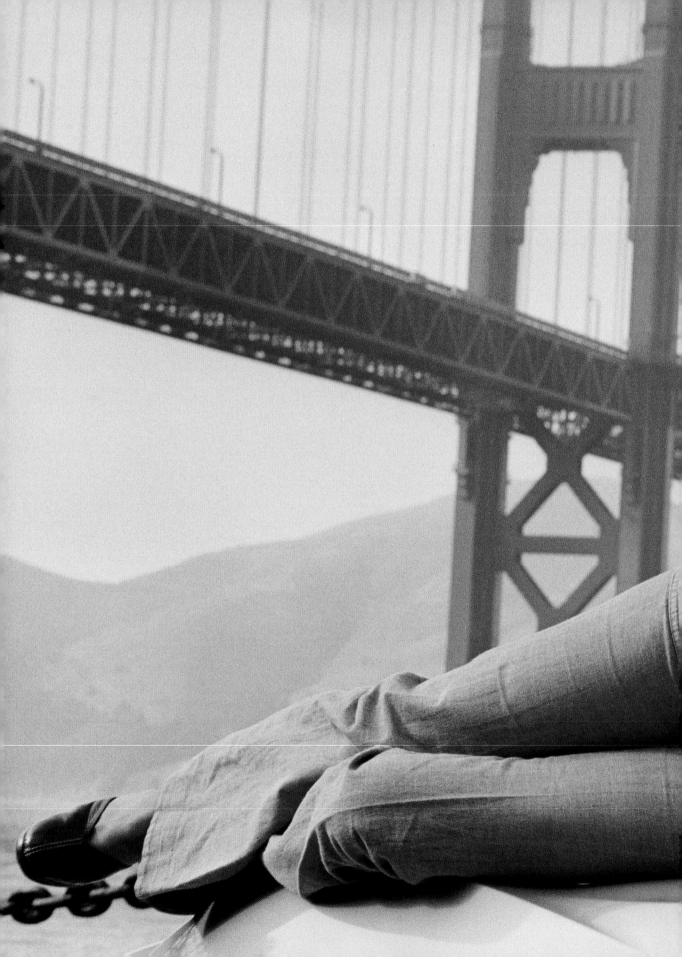

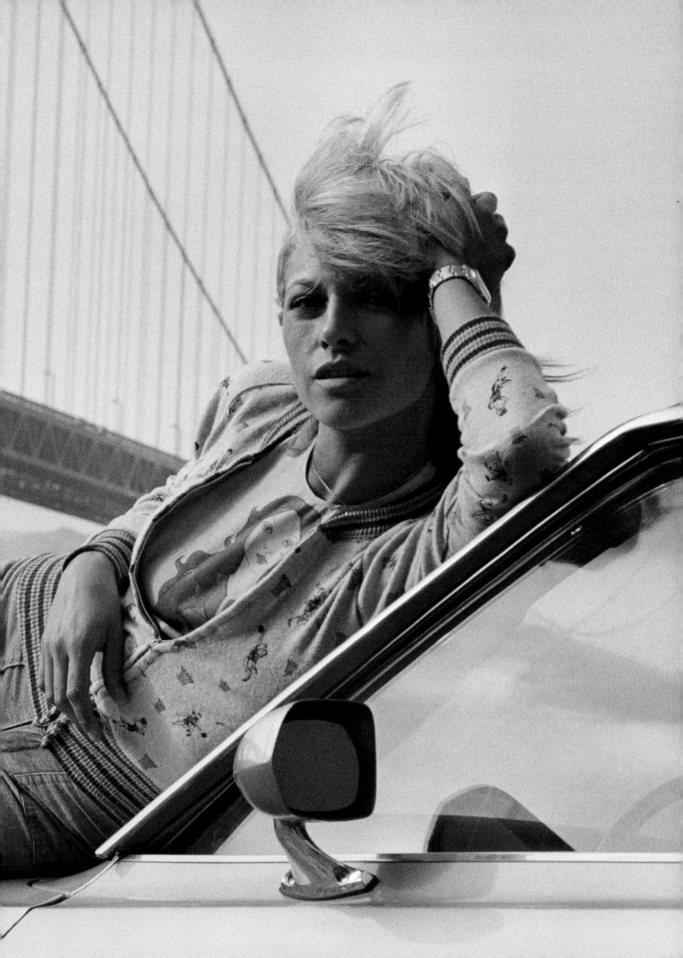

intro

by Lizzie Garrett Mettler

When I arrived on campus for my first day at Brooks School in North Andover, Massachusetts, I was thirteen and as plumb a tomboy as any. My two biggest thrills were making the varsity field hockey team and being mandated to wear a blazer to follow the school's dress code. While most girls griped about the tedious blazer rule, I was secretly thrilled.

I no sooner met Kingsley Woolworth. She was fifteen, blonde, leggy, and from New York City. She knew that exactly two blocks separated Henri Bendel's from Bergdorf's, how to hail a cab, how to apply mascara, and she had her older sister's driver's license tucked safely in the back of her wallet. She wore her mother's gold jewelry, painted her nails pale pink, and took pride in dressing her top bunk in Parisian linens. She wasn't delicate like many girls who match her description; she was confident, and could talk her way into and out of almost anything.

Kingsley and I became an unlikely but inseparable duo. When I broke my collarbone playing ice hockey, she decorated my sling with Lilly Pulitzer fabric sourced from a pair of my mother's vintage cigarette pants. When she feigned illness to avoid her American History exam, I visited her in the infirmary bringing my Patagonia fleece and an ice cream topped with Cap'n Crunch.

We admired each other's discriminating tastes, as different as they were. As time marched on, our styles quickly melded into one. Her sophisticated eye feminized my tomboy tendencies and my ruggedness brought her down to earth. She'd borrow my striped oxford shirts and tattered Lacoste polos, and I'd borrow her diamond earrings.

If teenagers classically want to identify themselves as "different," we wanted nothing more than to look like twins. We had identical pairs of Jack Rogers sandals, Belgian loafers, and men's Vasque Sundowner hiking boots—which we scrubbed with steel wool to hand-manufacture a broken-in patina. When we could successfully sneak off campus, it was straight to The Andover Shop, a local men's clothier unchanged for more than half a century. The tortoiseshell-bespectacled tailors had no idea what to make of us as we cinched our shirtdresses with as many men's ribbon belts as I could smuggle onto my parents' "emergency" MasterCard. It was never clear who was dressing more like whom, but undoubtedly we were each becoming more like the other. When I came home in the summer, my mother would have to undo the accidental New York accent I'd pick up from Kingsley. "It's pronounced LaGuaaardia, Lizzie, not LaGwordia," she would say as we pulled away from O'Hare. But even as I took from Kingsley's style and she from mine, we were both simultaneously creating an aesthetic that honestly reflected our true selves. While I never fully shook my inner tomboy, it was then that I graduated from a classic tomboy to a young woman with tomboy style.

That same balance Kingsley and I struck as friends years ago is present in my style today—a mix that allows for mobility and freedom without sacrificing femininity. Indeed, tomboy style goes leagues beyond the simple idea of borrowing from menswear: it penetrates into a woman's spirit, and no

duction

doubt her spirit penetrates the clothing as well.

I throw on my waxed cotton Barbour jacket and I'm transported to the house I grew up in, walking along the Middlefork Savannah with my mother. There's a muddy tennis ball in my pocket, and despite the bone-chilling mix of rain and snow, we are undeterred, and I throw the ball into the frozen prairie grass for my dog to retrieve. I button my chambray work shirt and suddenly I'm in Bondurant, Wyoming, with my husband clearing brush, building a ladder from fallen timber, and tromping in a forest of mingling aspens. I roll up my sleeves, put on a pair of work gloves and feel like nothing can get in my way. I put on my father's old glacier sunglasses and I'm digging into a plate of pommes frites in Switzerland, fortifying myself for a taxing afternoon of black diamonds with my brother. I lace up a pair of canvas deck shoes and I'm strapping heavy surfboards to the roof racks on my Jeep ready to dive headfirst into the icy Pacific before my 9 a.m. geology seminar. I slink into my husband's worn Levi's and at once feel petite and strong, sexy and comfortable, completely myself.

Every woman that identifies with tomboy style takes her own journey and collects stylistic artifacts that symbolize it. In the 1920s it might have been running out to buy a pair of trousers after seeing Coco Chanel's *garçonne* look on the streets of Paris. In the 1950s it might have entailed cutting up a pair of jeans and borrowing a sweatshirt in a Vassar dorm room for a game of touch football with a group of Yale men. It might have come from turning the pages of *Little Women*, or from watching tomboy icon Katharine Hepburn breathe life into Jo March onscreen. Or maybe it was Diane Keaton playing Annie Hall in her iconic ensemble (tennis racket over shoulder, polka-dotted necktie, black vest, chinos) that helped you embrace your inner tomboy. These women have become famous for denying the staples of classic feminine style, carving out their own definition of what it means to dress like a woman. They pushed the boundaries of conformity and carefully toed the line of limit's edge, refusing to give an inch, so that the next generation could push the boundaries even further.

As I've studied this look and become acutely aware of tomboys and their fashion sense, I've noticed the all-encompassing nature of tomboy style. Its umbrella covers everything from overalls to smoking jackets, punk shows to horse shows. The look has been embraced all over the world. But despite its great diversity, there is one consistent thread forever binding all these women: their spirit. Tomboys share an invisible intrigue cultivated from their inherent confidence, rebelliousness, and unquenchable thirst for adventure. There is something about what lies beneath these outfits that shines much brighter than any piece of cotton or silk ever could. Although there will always be sartorial beacons to identify tomboy style, even as fashion trends continue to ebb and flow as seasons turn, the clothing will only ever account for the thin surface of tomboy style. The complete look requires the right woman underneath.

the rebel

The rebel wears more than clothing, she wears a statement. I'll regret this? Just watch me. I'm not following dress code? Screw you. This gripping style combats convention and deliberately declares independence from the norm. When sartorial standards have instructed women to wear corsets, the rebels ripped them off. When women were required to wear skirts (not too high above the knee, mind you), it was rebellious icons like Katharine Hepburn who stood tall in pants, physically and metaphorically. These women burned their bras, cut their hair, played in punk bands, and turned heads—all while creating a new standard in fashion. To identify a true rebel, look beyond the ripped jeans, leather jackets, and metal studs, as this woman has the attitude to match.

My junior year of boarding school can be summed up in two words: mix tape. He had bleached hair, wore spiked belts, and played the drums. My friends looked on with disapproval, whispering, "She's just trying to rebel." It was as if he had a whole life behind him at the age of sixteen and the evidence to prove it: Link 80 ticket stubs, Operation Ivy stickers, NOFX T-shirts, and Misfits posters that covered the entirety of his red brick dorm room. We met one night at the flagpole before curfew and he handed me a mix tape. It was my first. I played it over and over and over again, reading intricacies into lyrics as if he were speaking them directly to me. As the rest of my dorm listened to a nauseating mixture of mainstream pop, I was engulfed by his compilation of abrasive downbeats, sweet emo melodies, and antiauthority lyrics. I smoked a cigarette in my room that night, just to feel the rush of breaking the rules. The tape told me to. I felt hard and bad, but mostly different. I held on to the tape long after our brief courtship, but I haven't forgotten the first track of side A: "I'm a Loner Dottie, a Rebel" by The Get Up Kids.

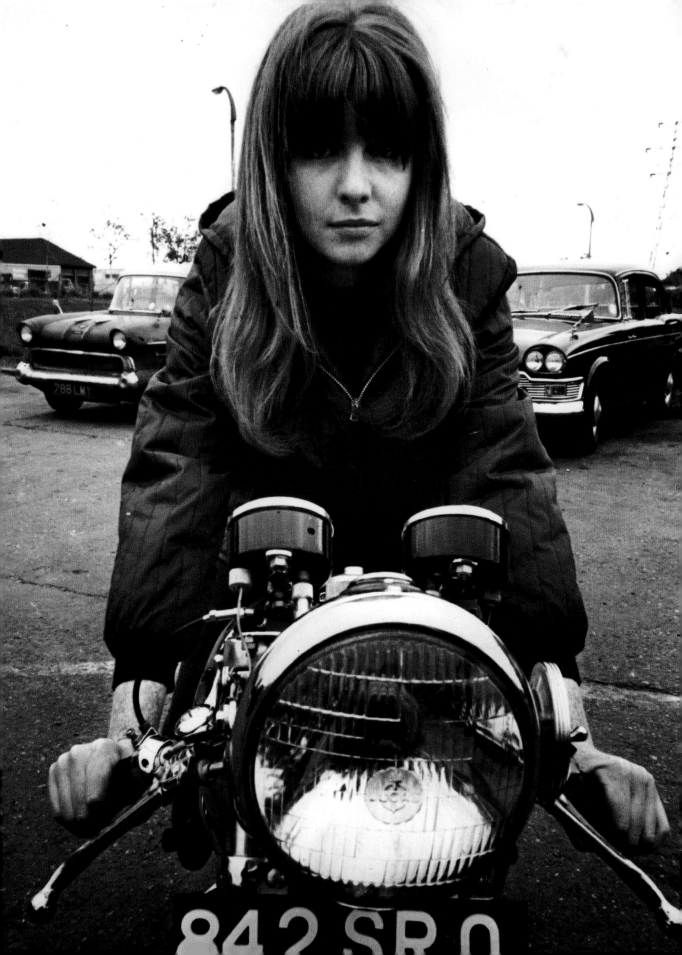

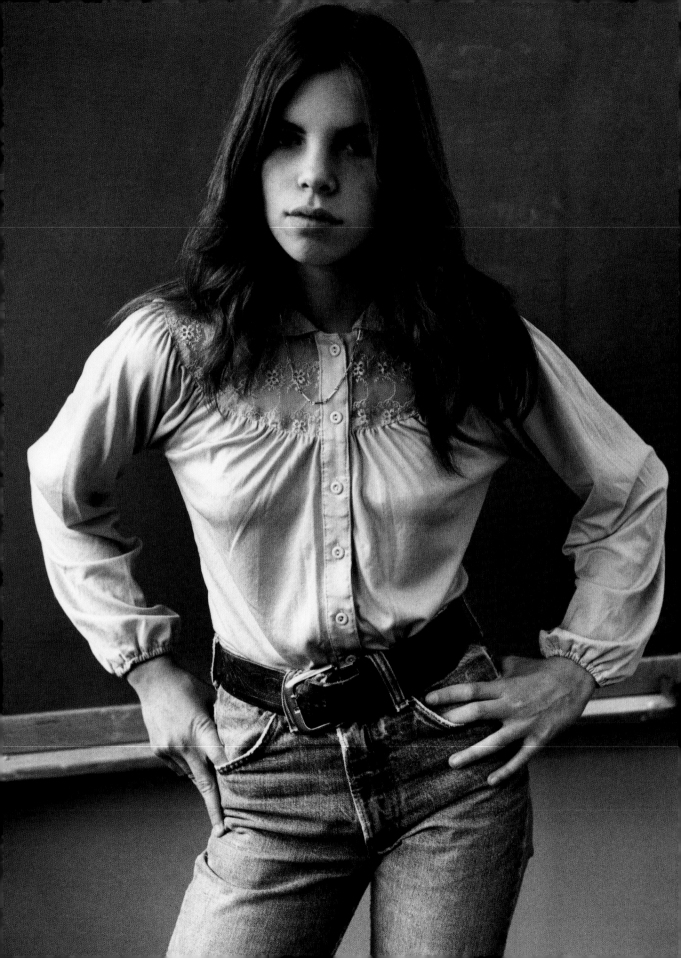

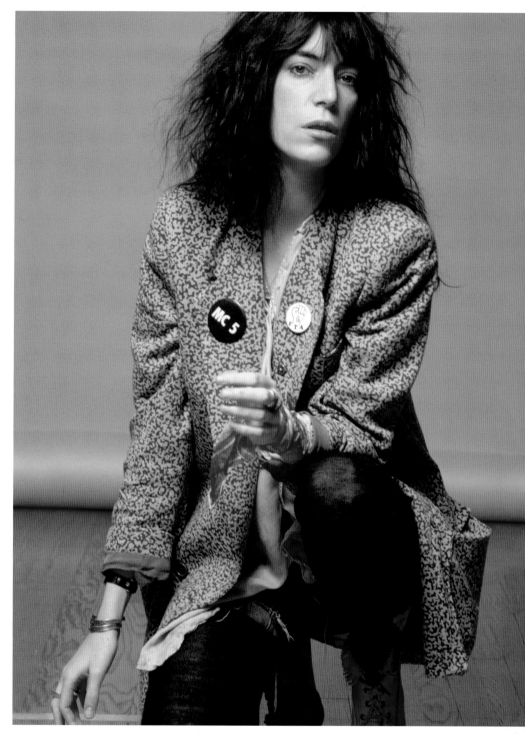

Poet Laureate of Punk

Just like the fabled New York City nightclubs where Patti Smith performed, her style harnessed a delicate authenticity that was impossible to copy. Photographer Lynn Goldsmith recounted that Smith loved French *Vogue* and shopping on Fifth Avenue and that she once bought an expensive green silk coat at Henri Bendel and then threw it immediately in the washing machine. She knew how to make the look completely hers.

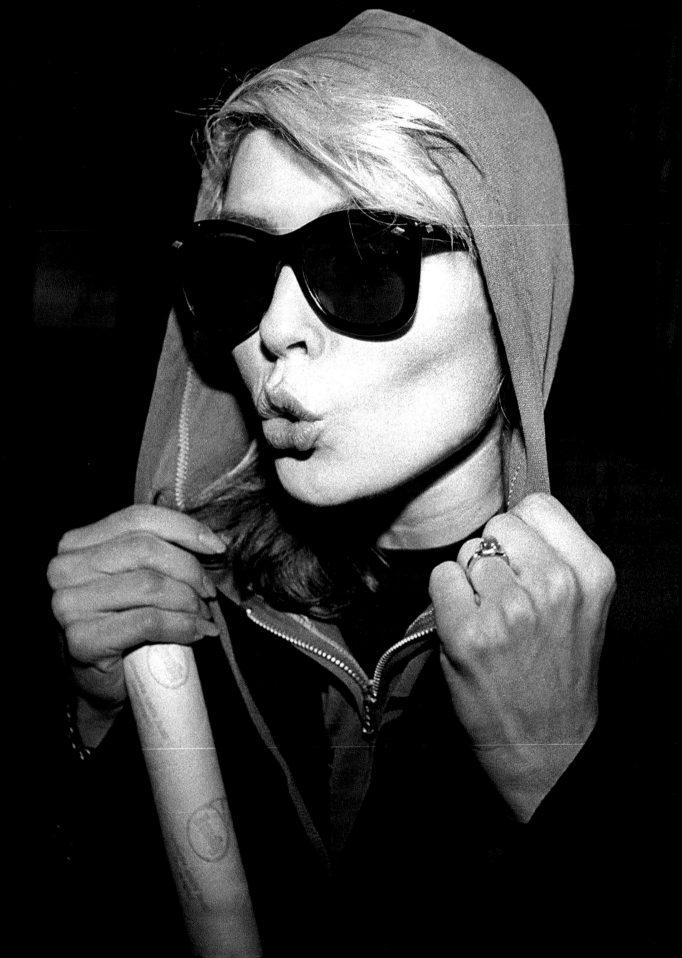

Glamorous Grit

New Wave frontwoman Deborah Harry effortlessly jumped between the glamorous world of Studio 54 and the gritty stage at CBGB. She oozed sex appeal in a T-shirt and wore platinum blonde hair with the toughness of a punk rocker. In 1981 she expounded, "People who are inhibited by the clichés of what women are or what men are, really don't like themselves. Because personality traits are not necessarily sexual."

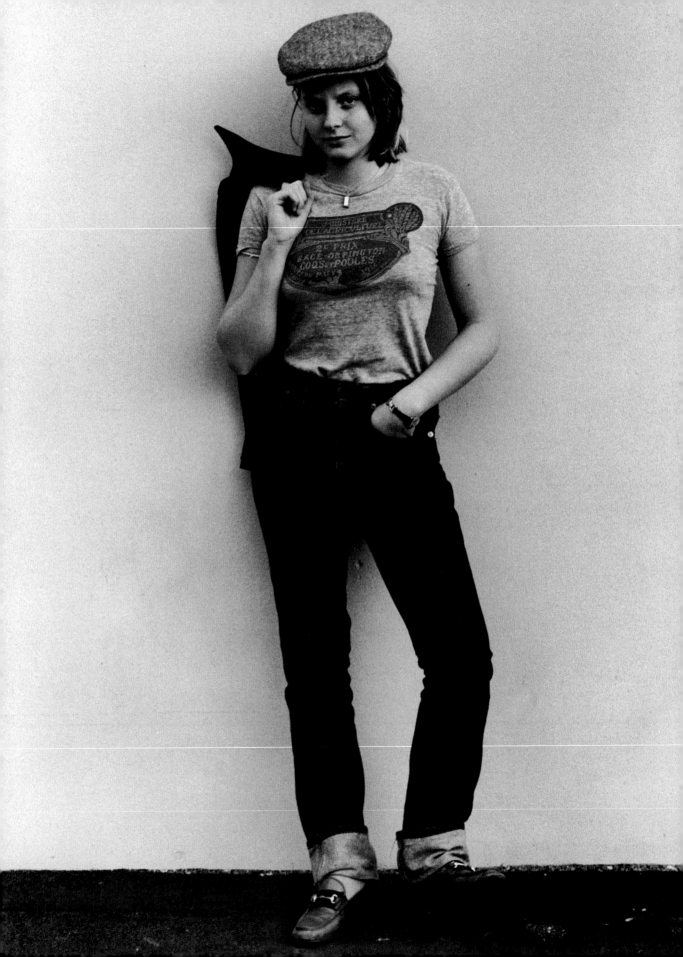

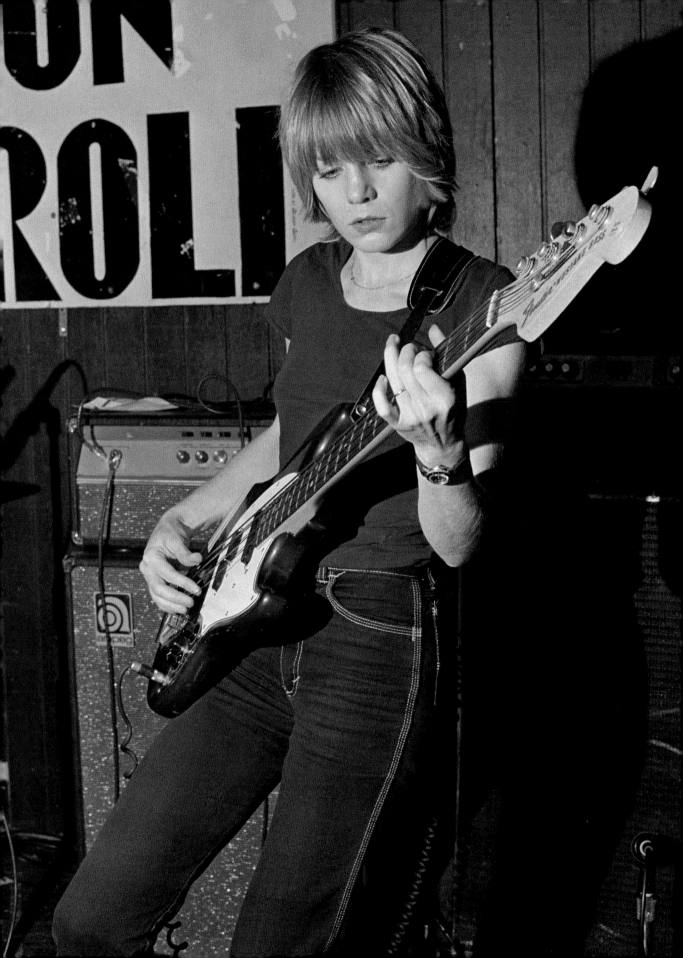

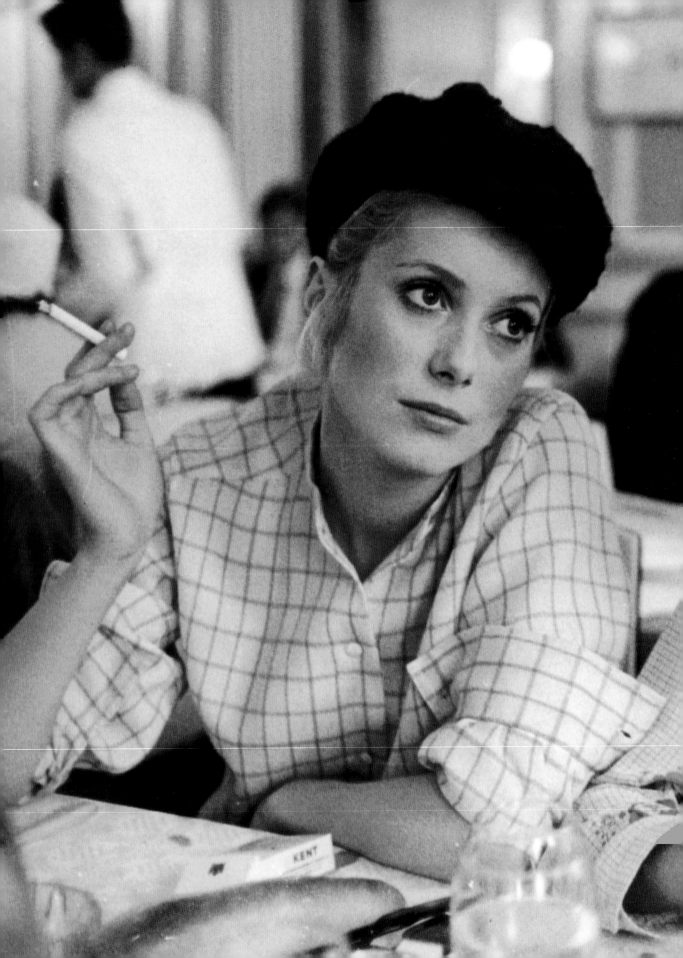

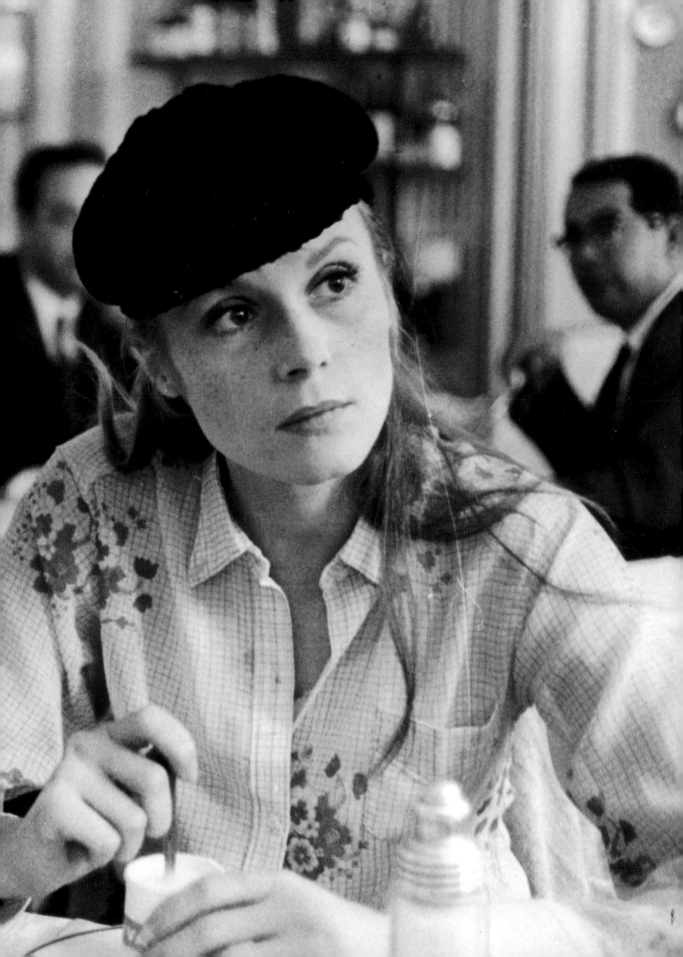

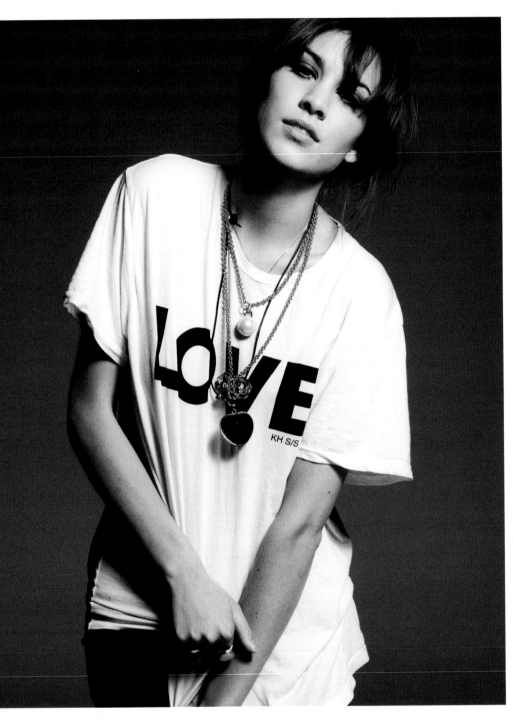

Brit Girl

Alexa Chung further popularized the tomboy look in the twenty-first century with her own well-honed eclectic style. A love for leather jackets, vintage tees, Barbour, striped shirts, and messy hair paired with a charming no-nonsense attitude is pure Alexa. Beyond the sea of fans from her stints as a television personality, Chung's collection for Madewell has garnered a major cult following, as do her DJ sets.

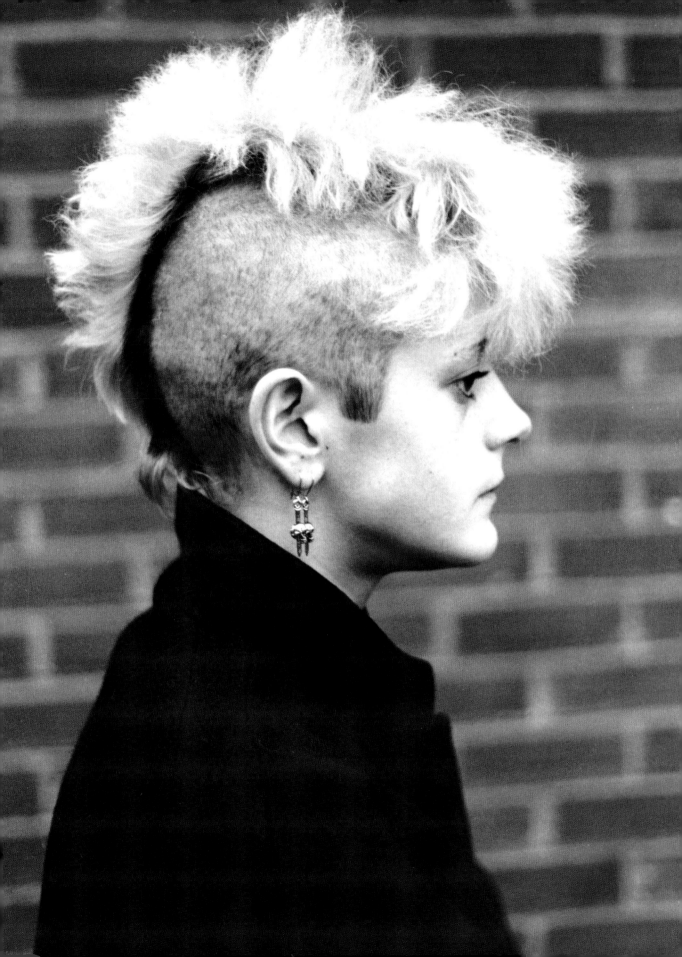

Love/Hate Relationship

Rolling Stone once called Courtney Love "the most controversial woman in rock history." Her bold lyrics and scrappy performing style have led many to see her as the female version of a male rock star, "from Iggy Pop in a shredded antique wedding dress" to "a female Lou Reed who screams like Exene."

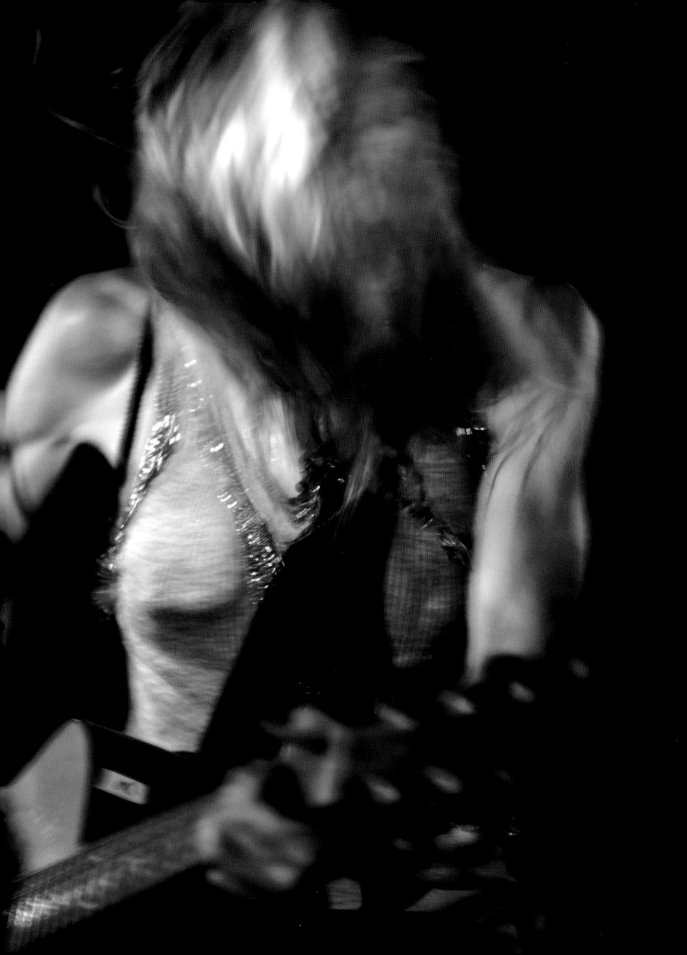

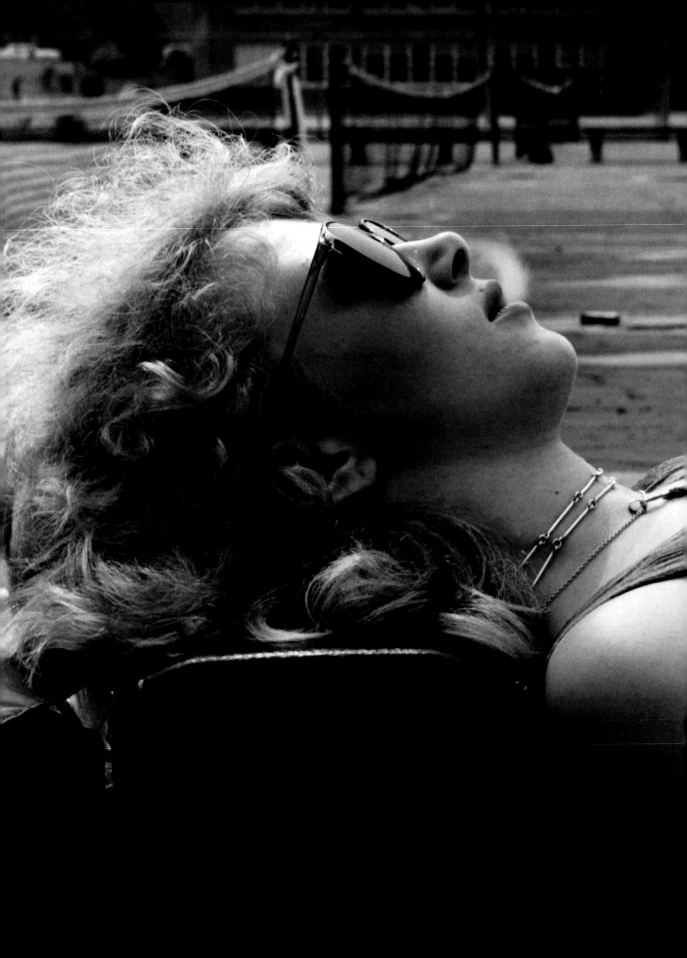

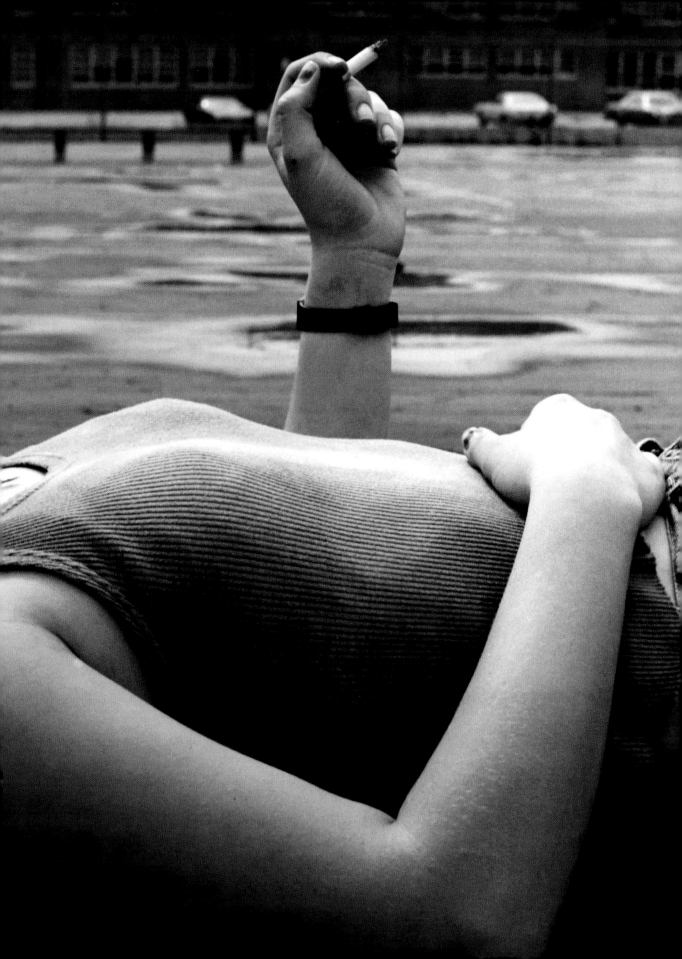

the sophisticated

From Coco Chanel's invention of women's sportswear, to Marlene Dietrich's nights spent sauntering around Paris in a top hat and tails, to Yves Saint Laurent's iconic Le Smoking jacket, there have been several markers in the evolution of glamorous androgyny. A freeing sensation paired with a sleek and svelte core makes this look so attractive yet enigmatic. It is difficult to imagine a time when a woman in a suit was considered taboo, but it is hard to deny that a woman can be much sexier in a tuxedo than in a ball gown.

My first magazine job was working as an editorial assistant at Condé Nast in L.A. The pay could be generously described as meager, but I couldn't wait for Monday mornings. Turning on the office lights was a powerful feeling. In the bullpen I benefited as much from my fact-checking assignments as I did from overhearing the esoteric conversations of the editors I idolized. They spoke about Phoebe Philo,

Hedi Slimane, vermouth, French *Vogue*, vintage Porsches, and peaked lapels with the same pace and meter as one might recap an episode of *Friends*. In time my style icon was becoming less Jackie O and more James Bond. I'd leave work high on their inadvertent daily lessons in cool, and motor to the Paul Smith store on Melrose, just so I could mentally grab at the clothing and the world they represented. There was a silky black tuxedo jacket that started to seduce me, but it was way too much for my salary to support. Still, when I tried it on I felt like I had some sort of power, like I was turning on the lights to my own corner office. I could imagine myself in it carrying important papers and then ordering a Manhattan. A month of lust and several skipped meals later, I finally bought "the jacket." It took me four months to pay off, but in it I had authority. I had a job. I was independent. I was confident. I was sophisticated.

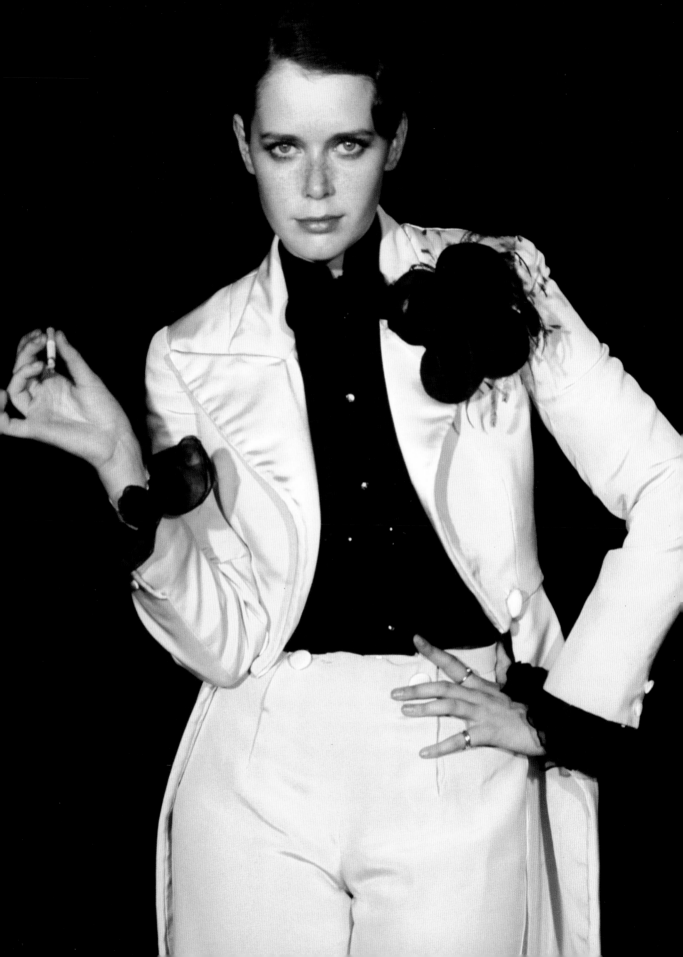

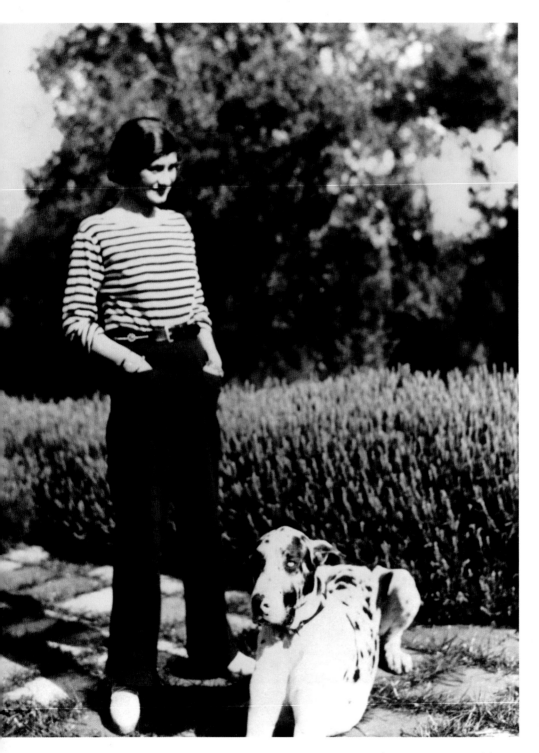

The Godmother

In the tomboy style universe, Coco Chanel was the big bang.
She introduced sportswear to Parisian women in the early twentieth
century after experimenting with borrowed duds from her male compan-
ions, including Captain Arthur Edward "Boy" Capel and the Duke of
Westminster, whom she never married, because, she said, "There have
been several Duchesses of Westminster. There is only one Chanel."

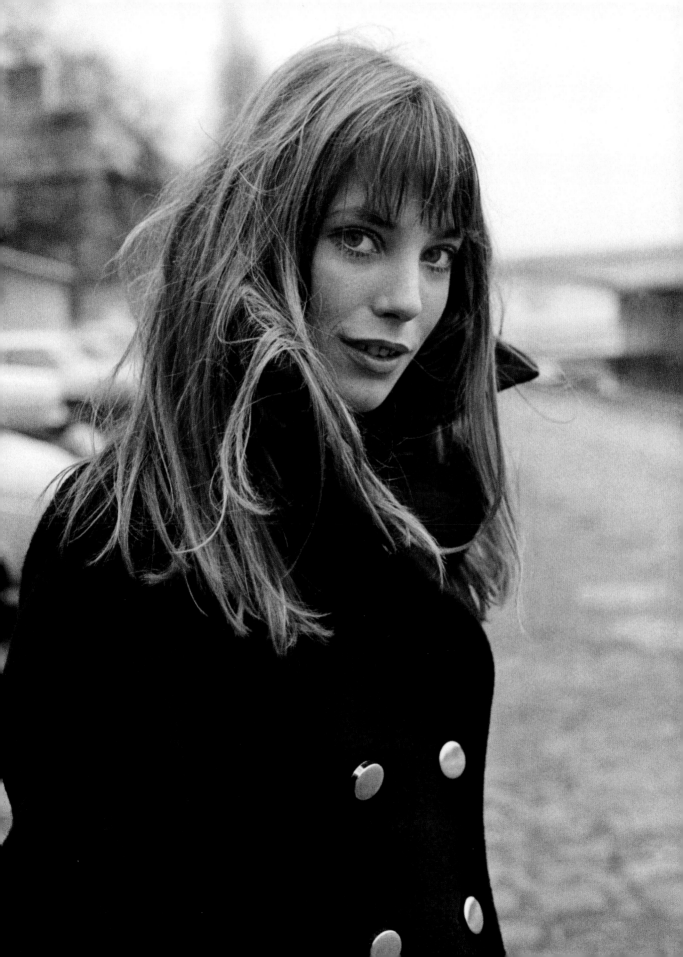

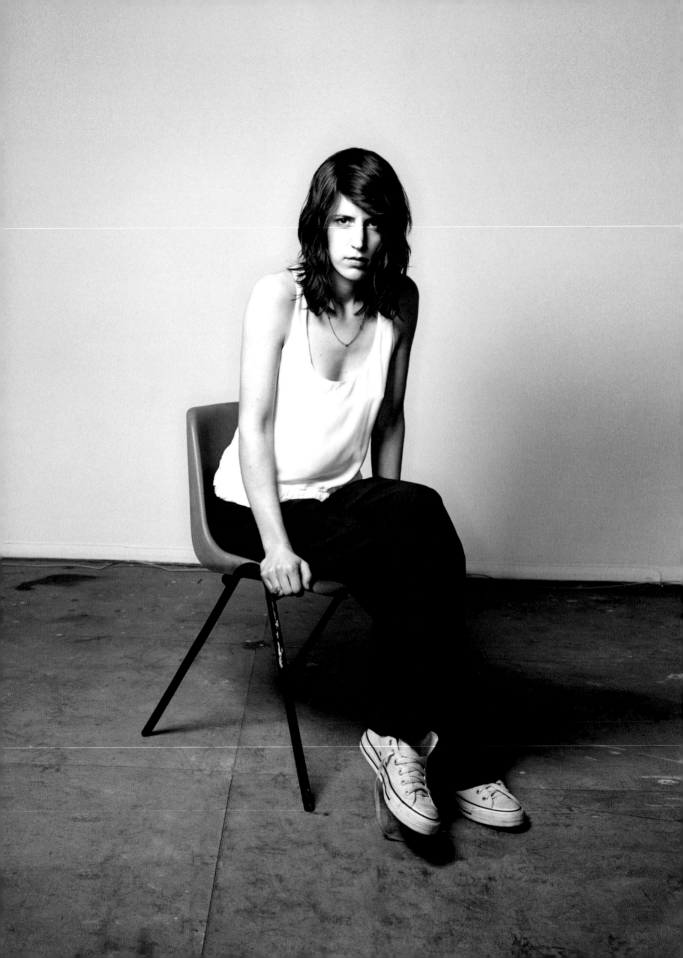

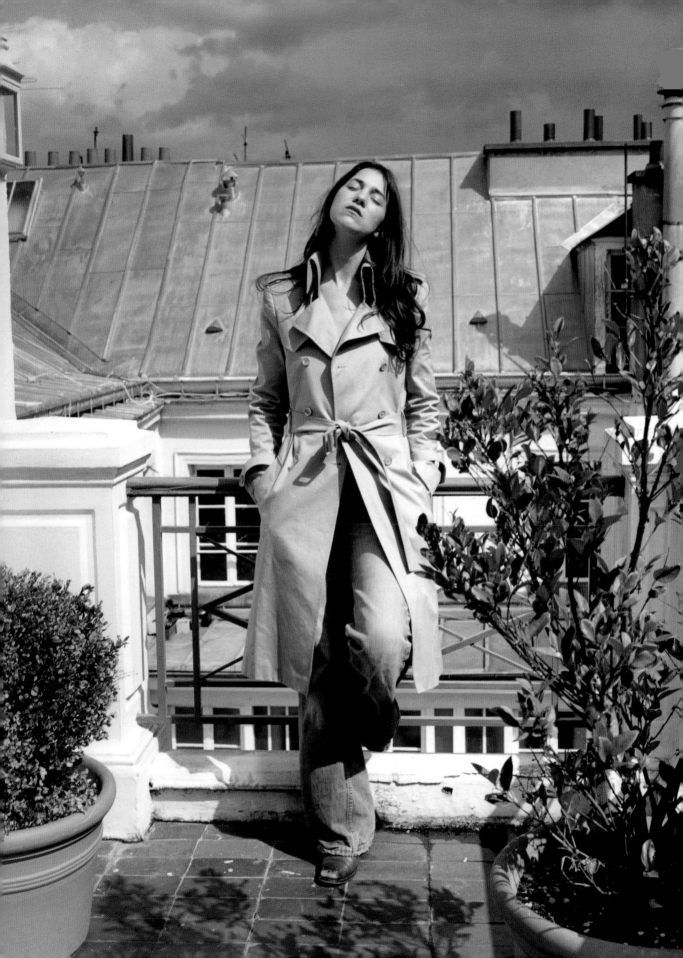

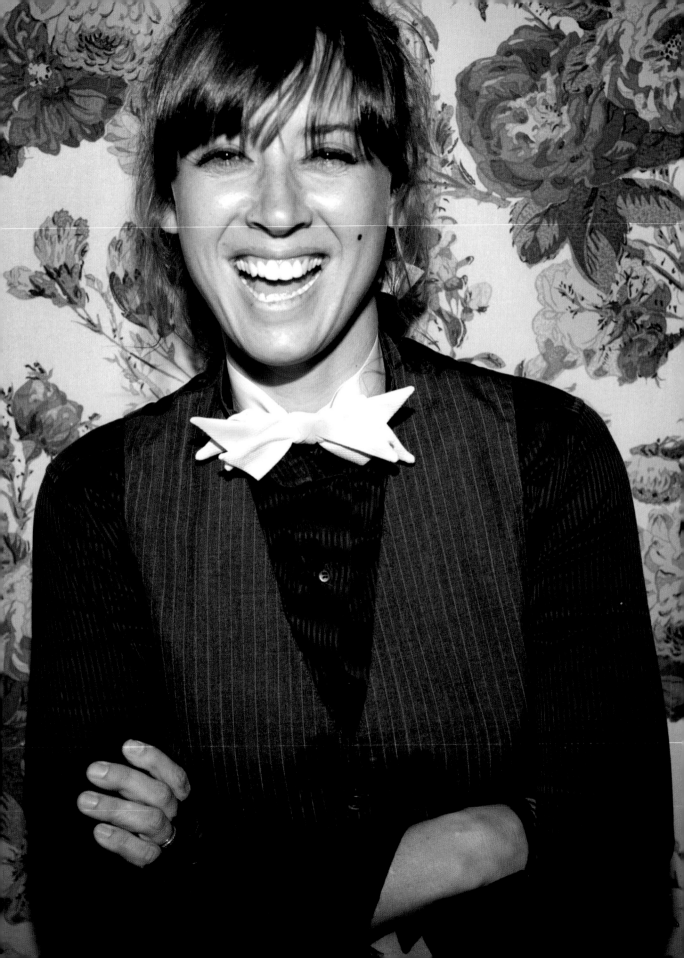

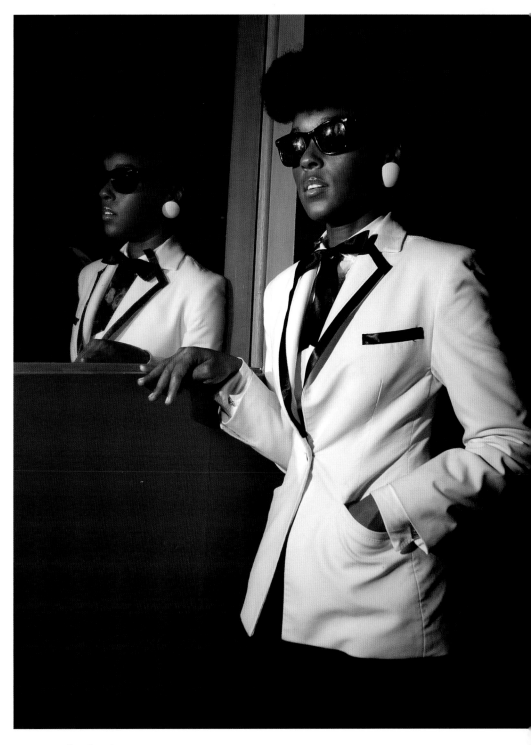

Tux it Out

Singer Janelle Monáe's stage performance has recalled the likes of James Brown, Prince, and Stevie Wonder. Her stage uniform of sleek riffs on the classic tuxedo has cemented her a place in the fashion world as well. Monáe makes her sartorial choices in hopes of influencing how young girls interpret how a woman should dress. She said, "I don't believe in menswear or women's wear, I just like what I like."

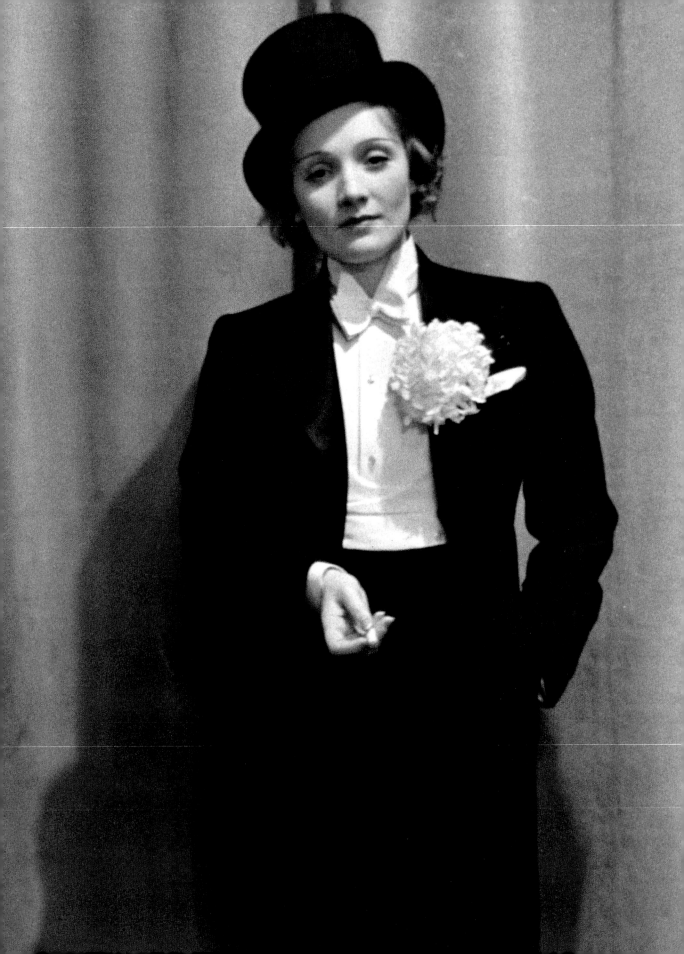

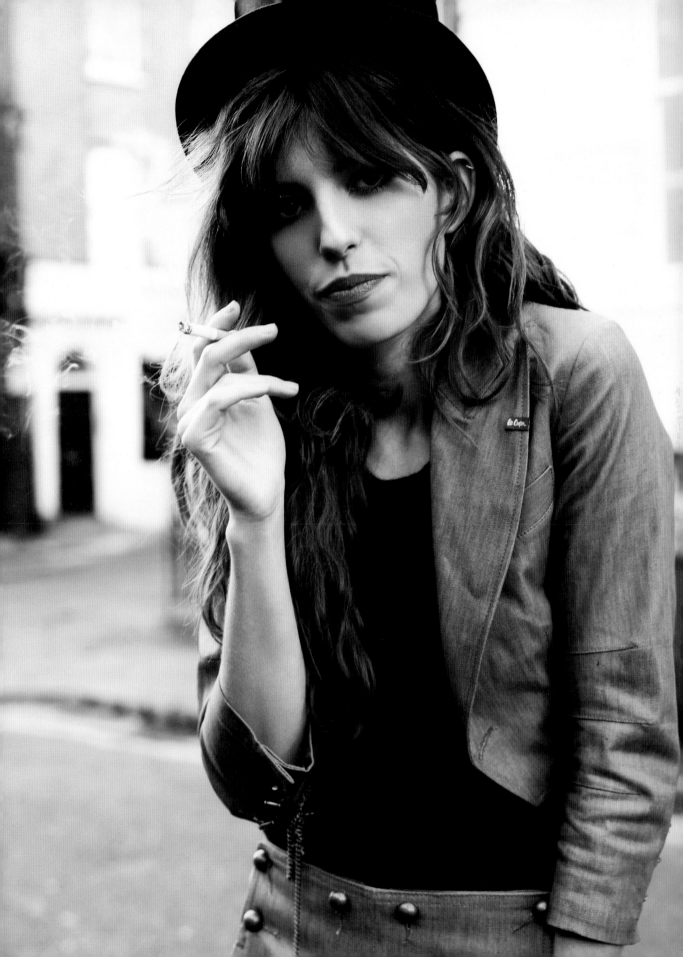

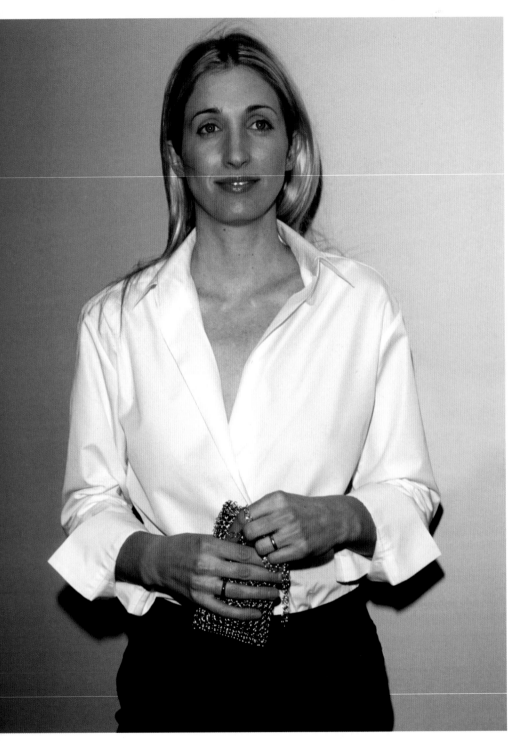

American Classic

Carolyn Bessette-Kennedy captured the world's attention with her non-chalant elegance and minimal style. While she could dazzle in a gown or a simple Calvin Klein dress, her true style was elevated to its peak when she wore black suits, none-too-tailored white button-down dress shirts, unfussy hair, and sparing makeup with her signature pop of bright red lipstick.

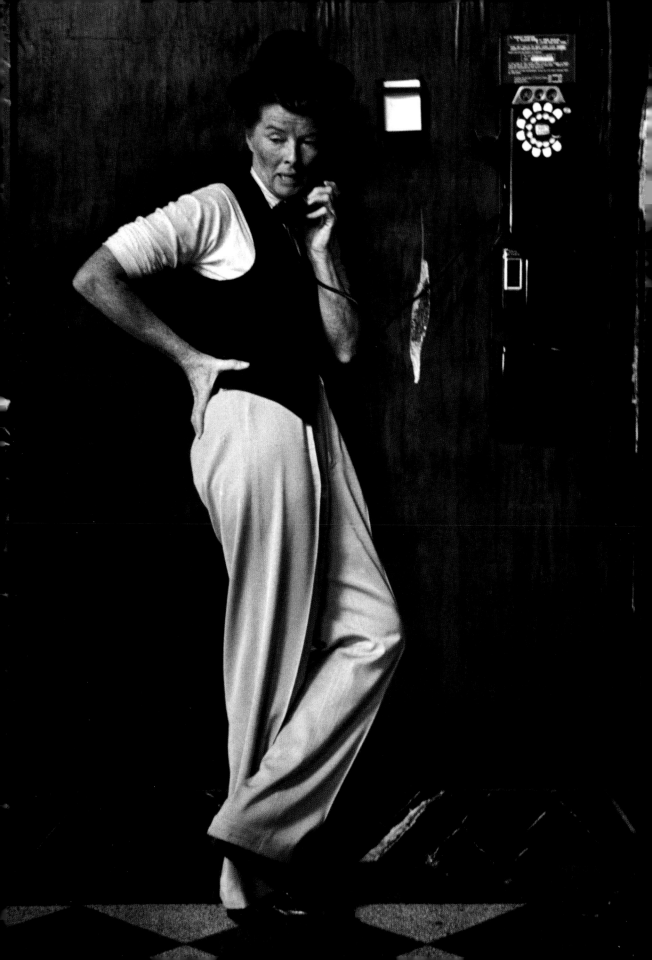

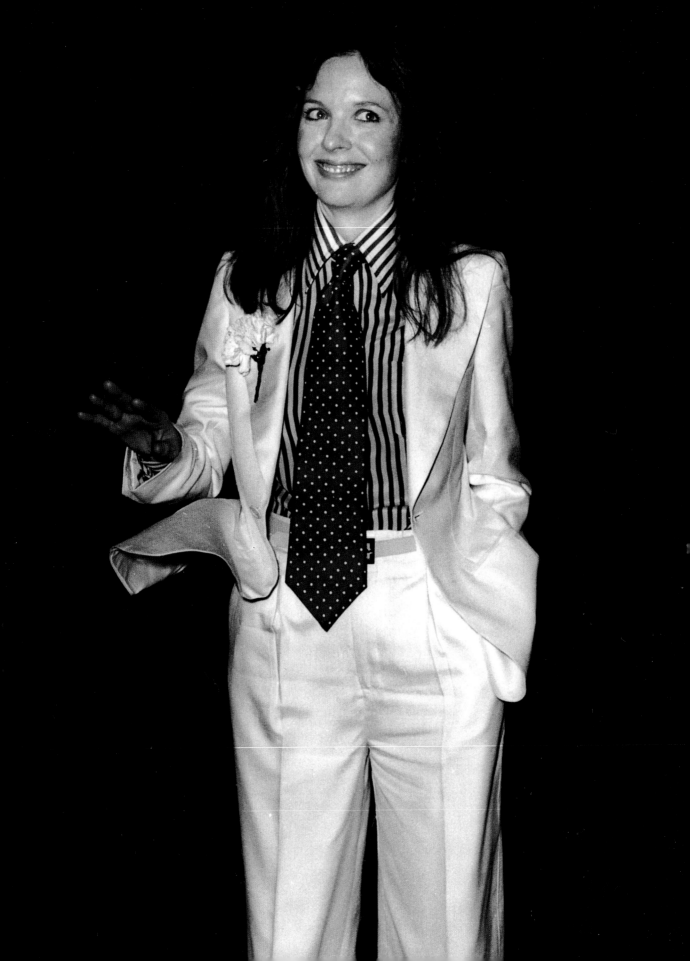

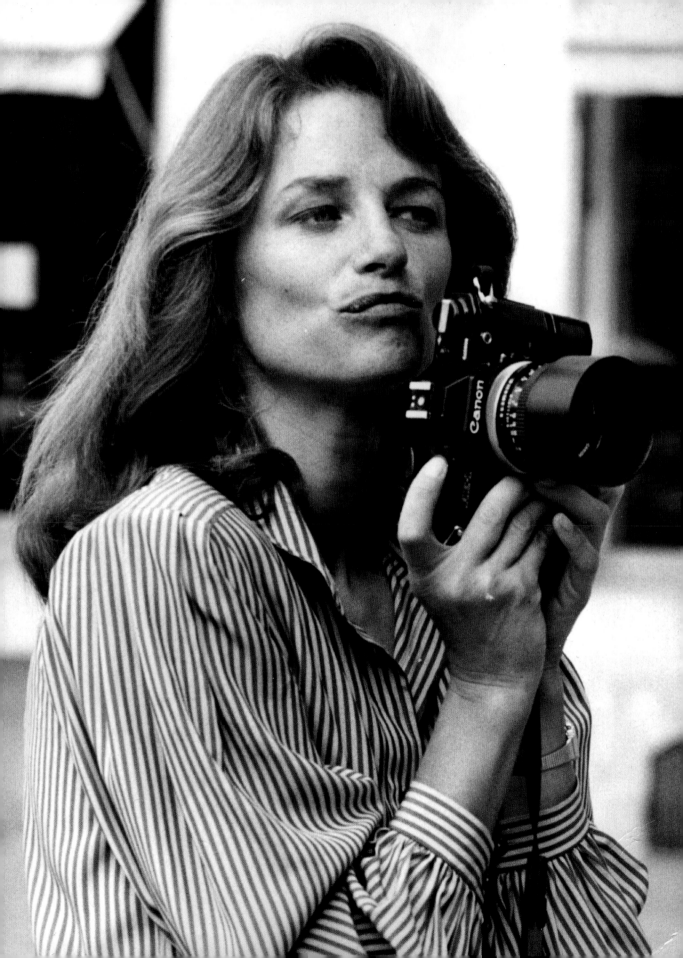

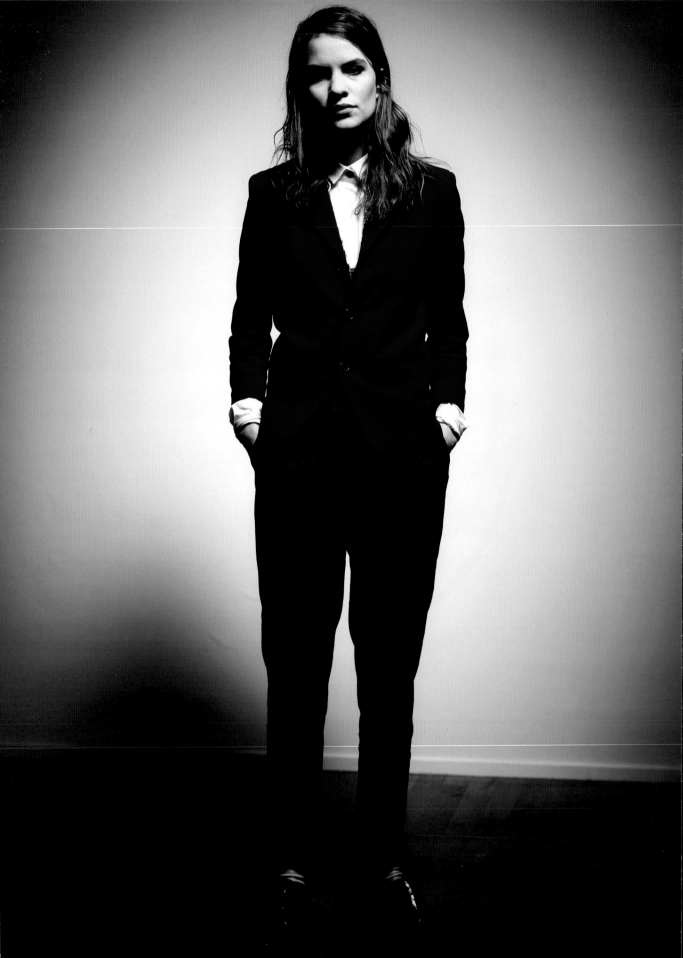

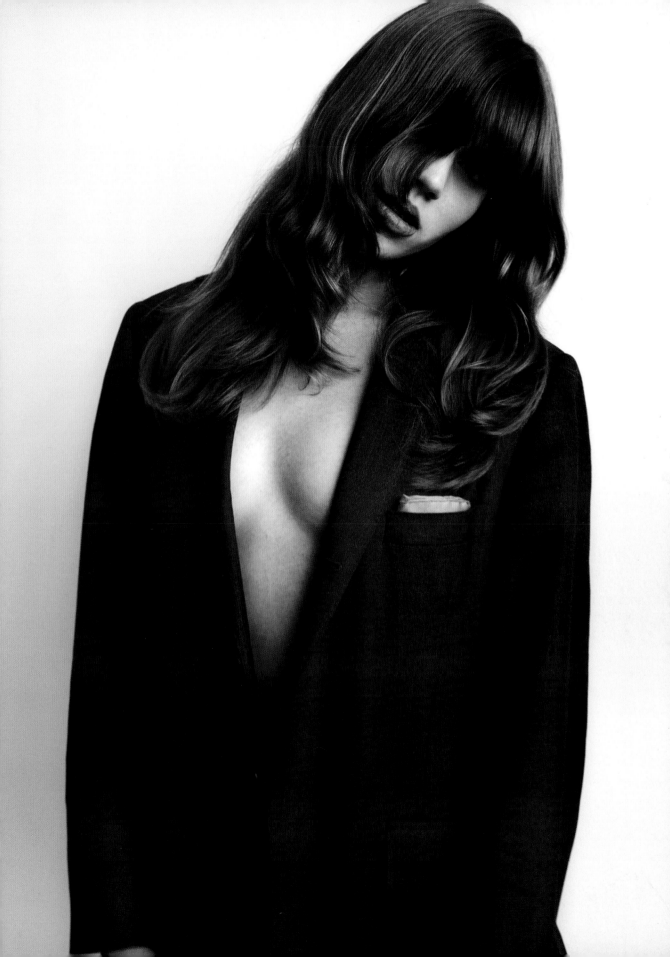

the jock

Sometimes a trait as simple as physical coordination can help define an identity. From the sole girl on a Little League team exiled from the boys' locker room to record-shattering Olympians, these are the women who are addicted to the thrill of competition. They yearn for the taste of victory and are unrelenting in their quest to compete. They are tough. Often female jocks have been cast aside on account of their gender and denied the chance to show what they're made of, making their competition twofold: a fight to compete and a fight to win. Not only did these pathbreakers challenge the notion of what a woman should do, they were steadfast in proving what a woman could do. The women before us have pushed social boundaries while pushing their bodies to the limit. In doing so, they ensured that younger generations of girls hardly question whether they should hit a ball, catch a wave, or proudly throw like a girl.

When I was old enough to be signed up for my first softball team, I was ecstatic. The league in my town was called Bobby Sox—a name derived from a folded ankle sock adorned with lace and typically worn with poodle skirts and saddle shoes. Luckily, I didn't have that historical context at age seven, because if I had, it would have been a deal breaker. All I really cared about, though, were uniforms. I wore a white AYSO jersey with royal blue piping for the better part of 1989. When I stood in line to get my first Bobby Sox uniform, my heart felt like a machine gun. All the important questions were filing through my head: What number would I get? What color were the stirrups going to be? Will the pants have belt loops? The anxiety almost knocked me out. When at last I approached the man with a clipboard, he handed me a pair of red shorts, a plain red cotton V-neck, and a plain red mesh hat. No stirrups. No logos. No team. No number. This was clearly a mistake. I looked right at the man and asked, "How will I slide in shorts?" He giggled. "Girls don't slide, sweetie." I ended my relationship with softball then and there. From that day forward, I played boys' baseball.

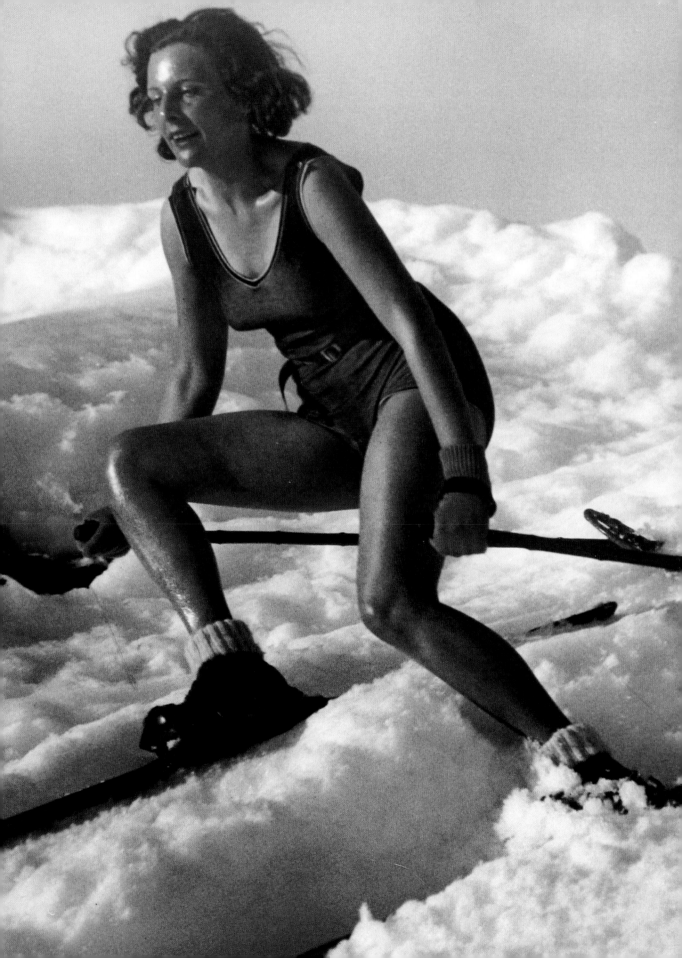

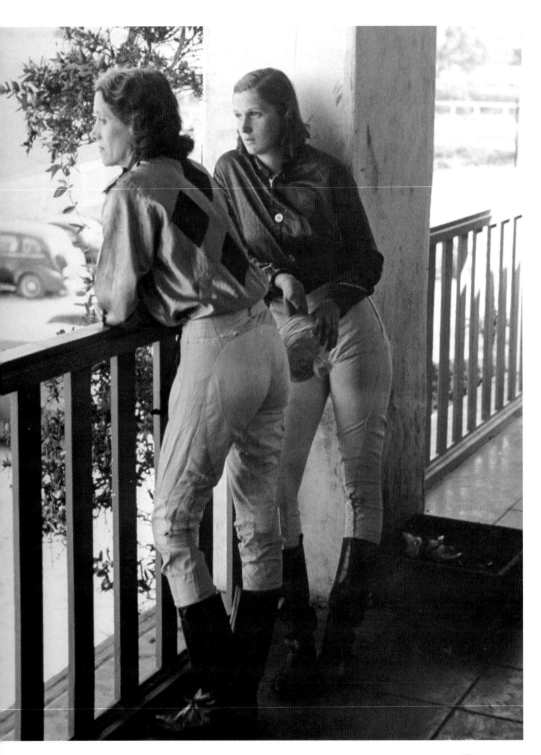

A Day at the Races

In 1940 little opportunity existed for female jockeys. The Agua Caliente racetrack in Tijuana, Mexico allowed women to compete in a Powder Puff Derby twice a year. Rodeo performers and thrill seekers from all over the nation flocked to the track. They borrowed silks and pants from men, often two sizes too big, and raced like hell for a chance at winning first prize—a brand-new wristwatch.

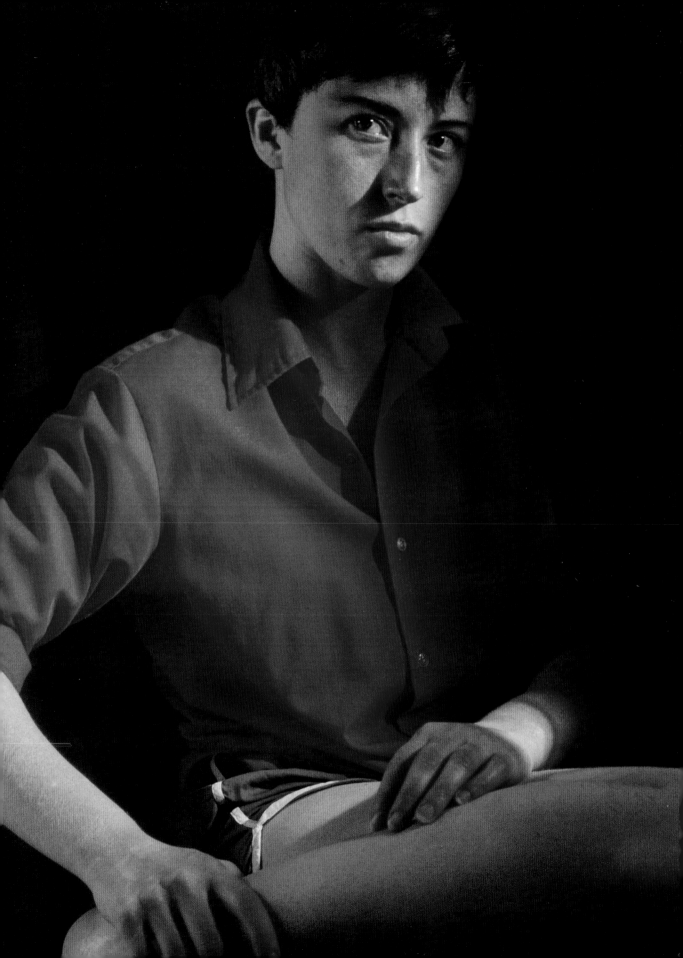

Society Surfer

Minnie Cushing Astor's socialite pedigree is impossible to deny. She and her two younger sisters, Babe Paley and Betsey Whitney, the "fabulous Cushing sisters," were famous for marrying into some of the nation's most powerful families. Still, Minnie often traded her luxury car for a bareback horse or her couture gown for a wetsuit to catch waves off the coast of Newport.

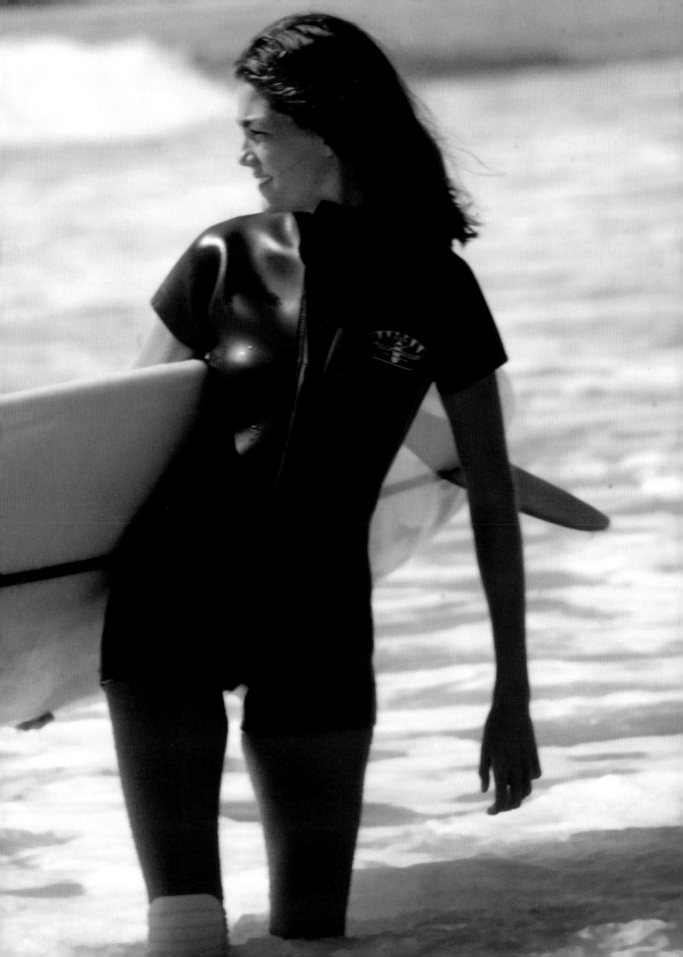

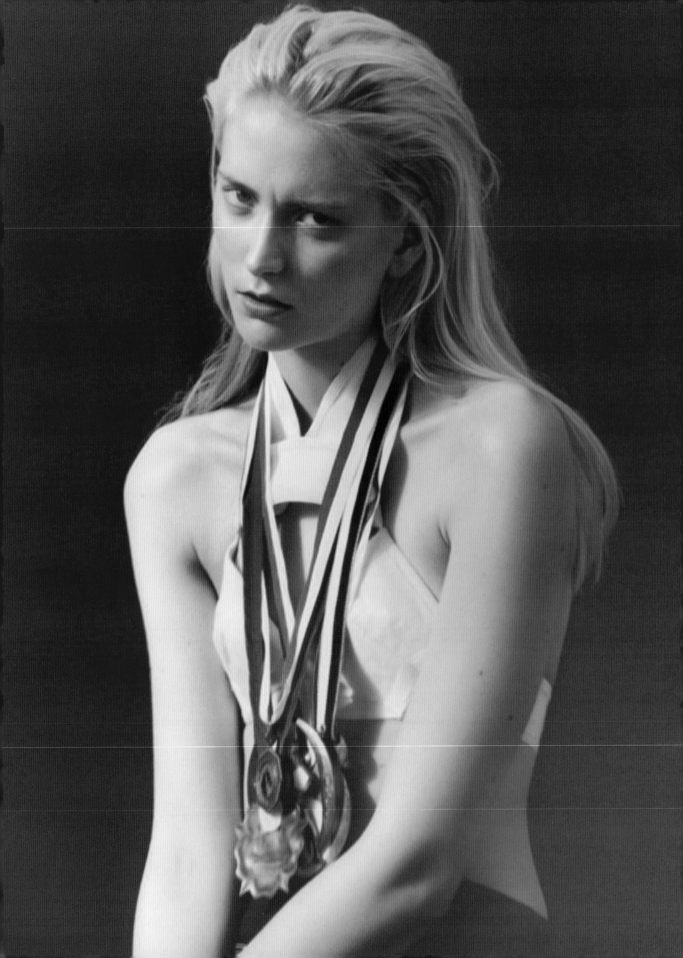

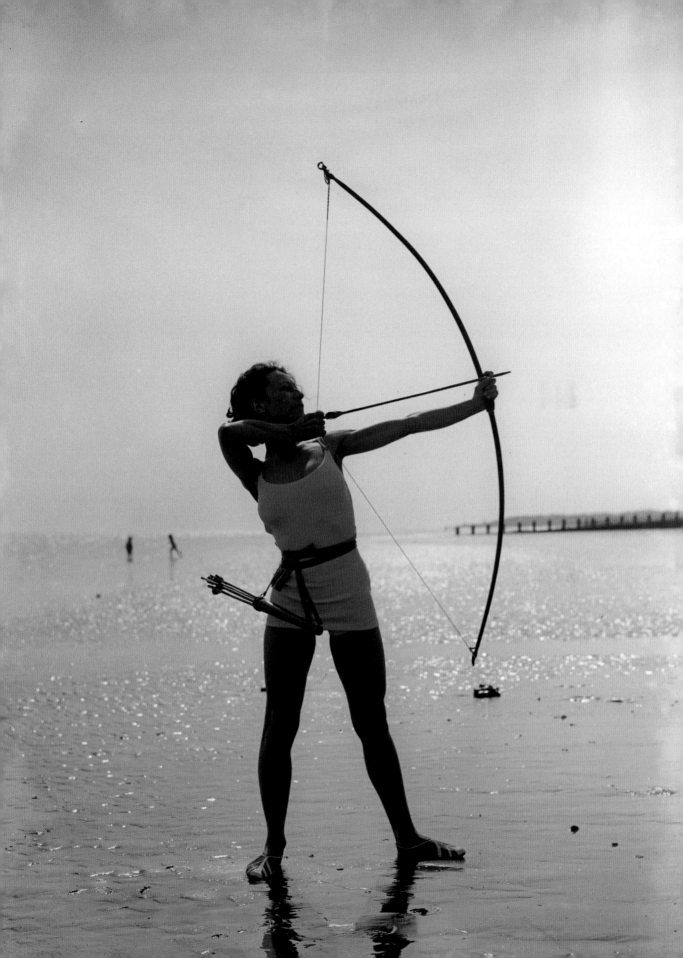

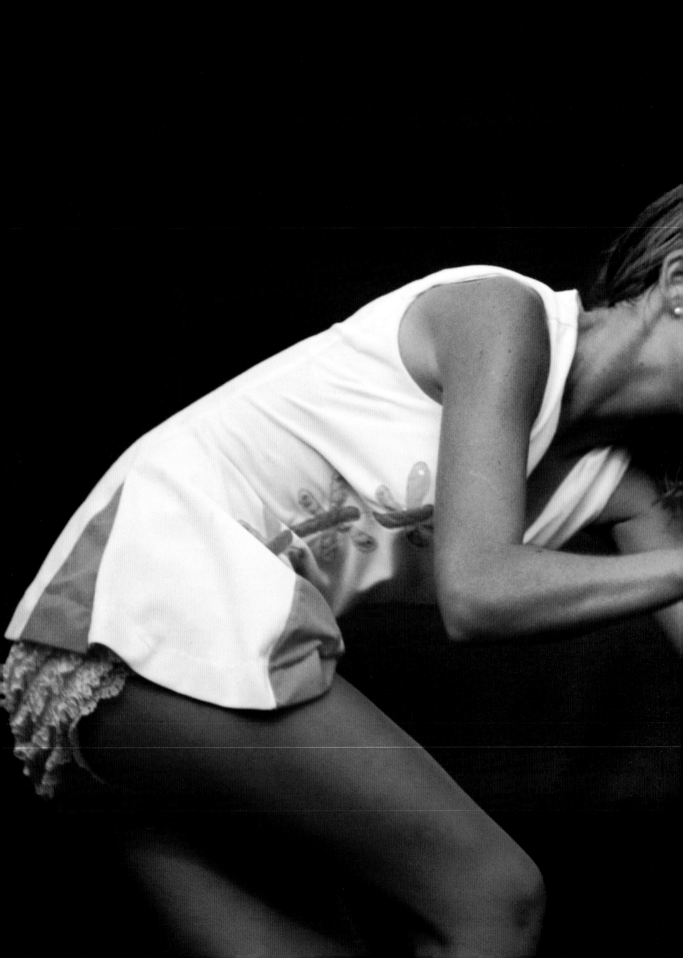

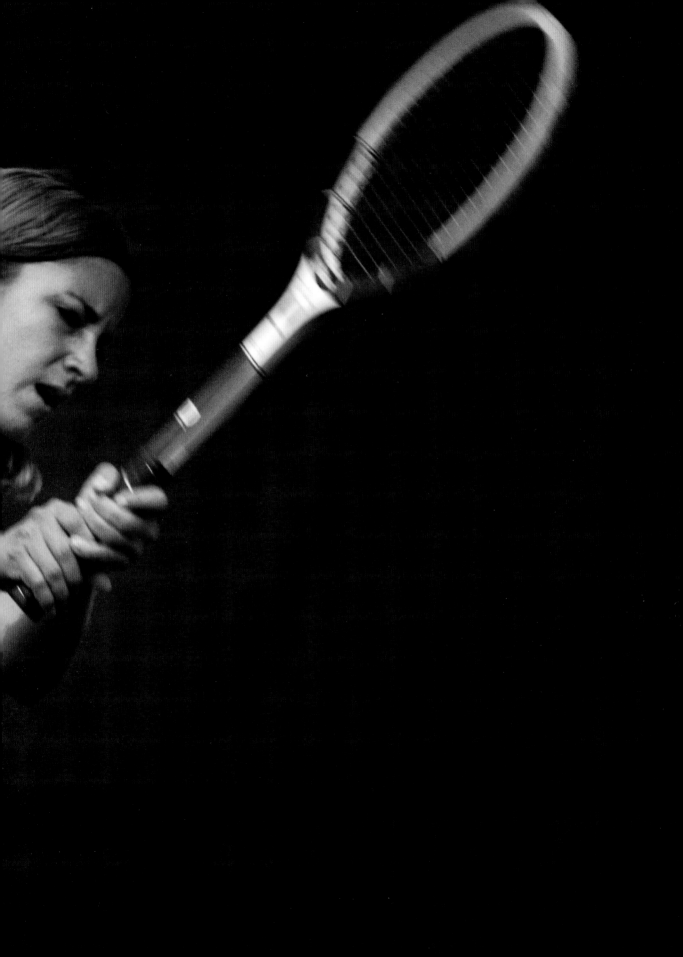

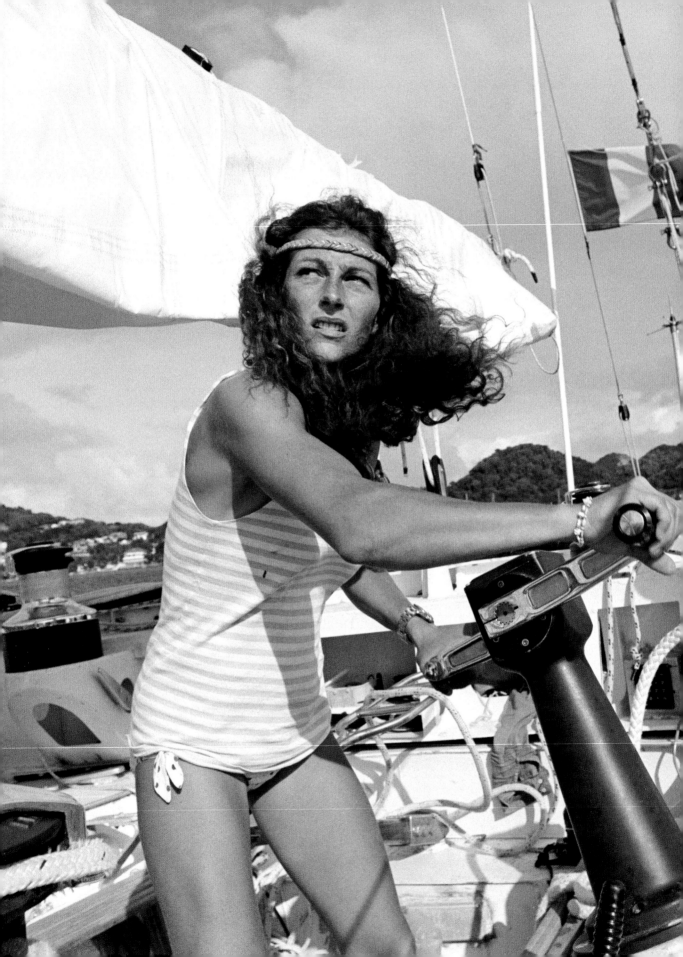

Captain Courage

French sailor Florence Arthaud broke the Route du Rhum record in 1990 when she sailed solo across the Atlantic from Saint-Malo, Brittany, to Pointe-à-Pitre, Guadeloupe. Arthaud is known as "the Sweetheart of the Atlantic," but it takes more than a sweet heart to single-handedly navigate an ocean; it takes muscle and guts too.

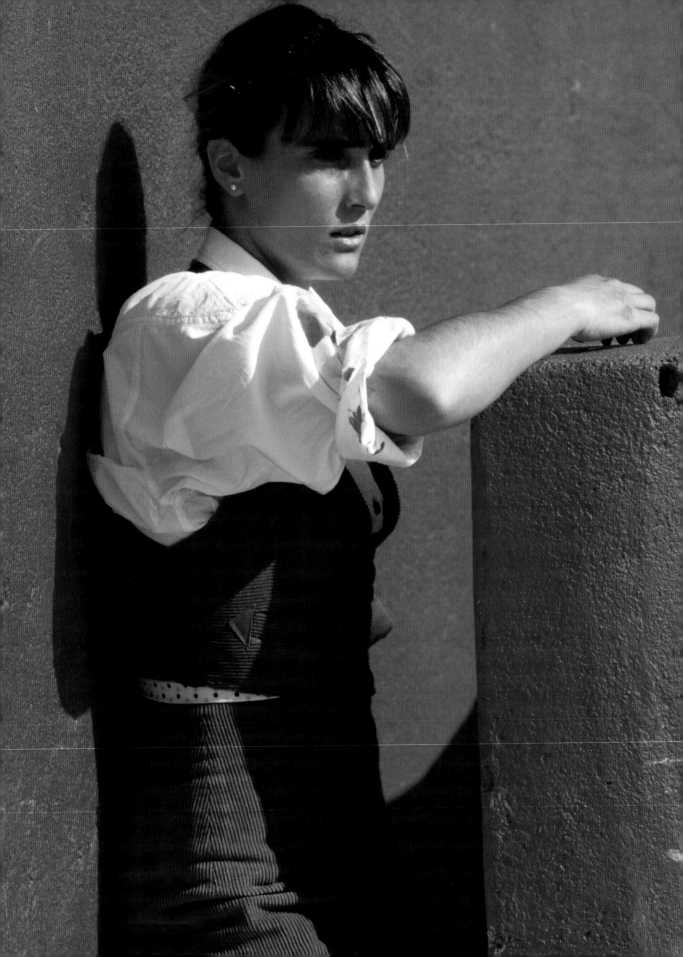

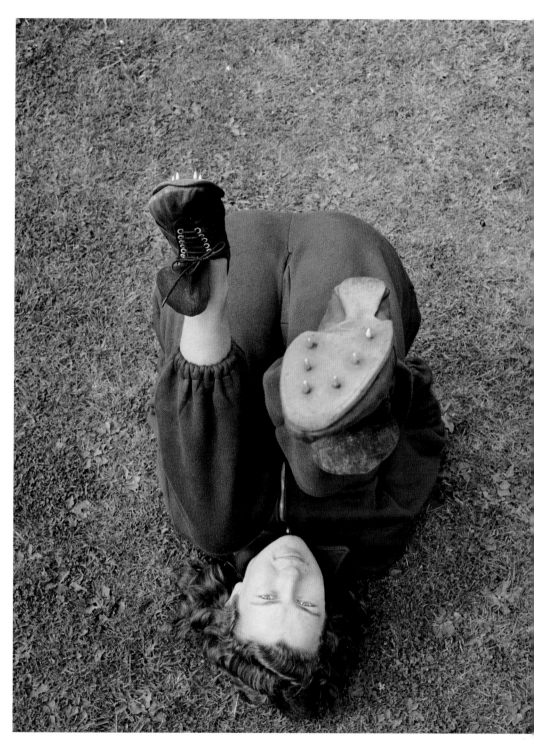

Spiked Up

There was much debate as to whether to hold the 1948 Olympic Games in London after a twelve-year hiatus due to World War II. It turned out to be an uplifting moment for the world and proved to be extremely popular. Women represented just 10 percent of the Olympians then, one of whom was South African 100-meter runner Daphne Robb-Hasenjäger, who trained in spikes and a sweatsuit.

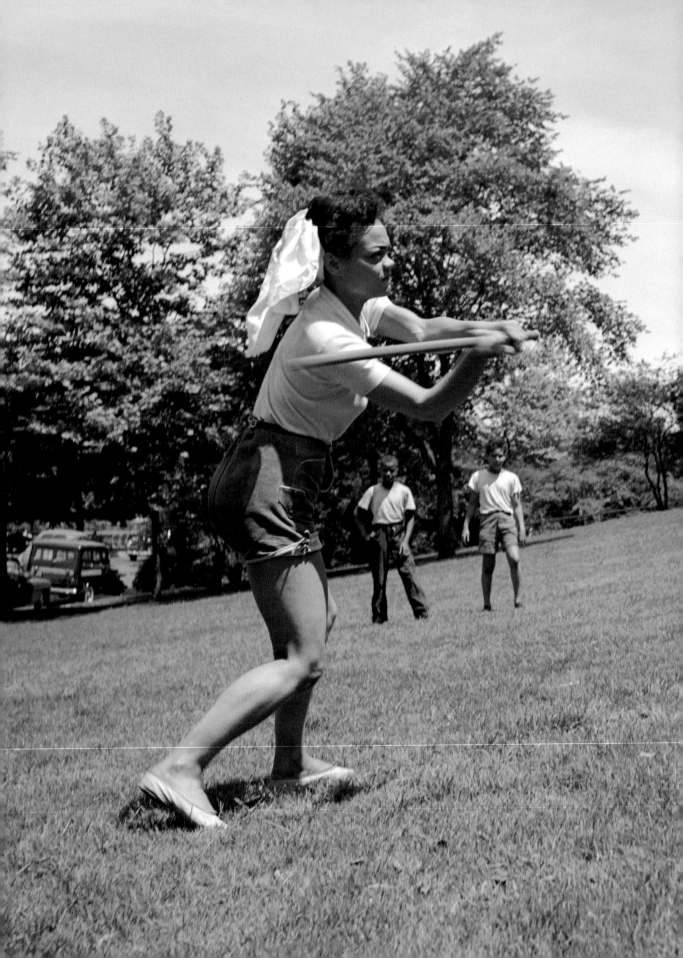

Ball Girl

Singer, Broadway darling, and baseball lover Eartha Kitt had to persuade a group of boys to let her play with them by bribing them with ice-cream cones. The young ballplayers were impressed with Kitt's skill once they saw her in action, and they even continued to meet twice a week in Central Park.

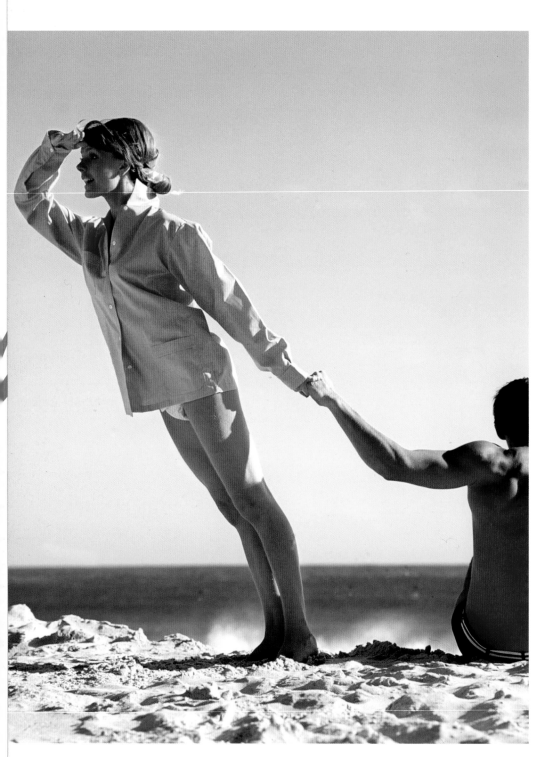

Sixties Shirt

While 1967 may best be remembered in fashion for its flower children dancing away the Summer of Love, or for the lacy romantic ruffles seen on swinging men and women, the collared shirt was also omnipresent. Indeed, collared shirts were seen belted as dresses, used as structure pieces under sweaters, or simply as oxford-cloth beach cover-ups.

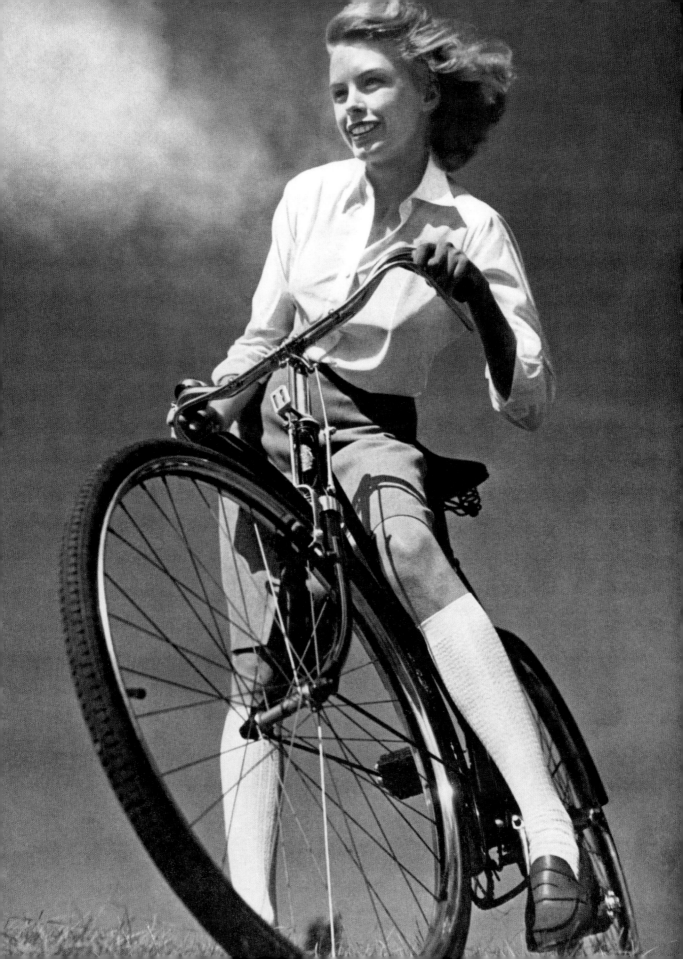

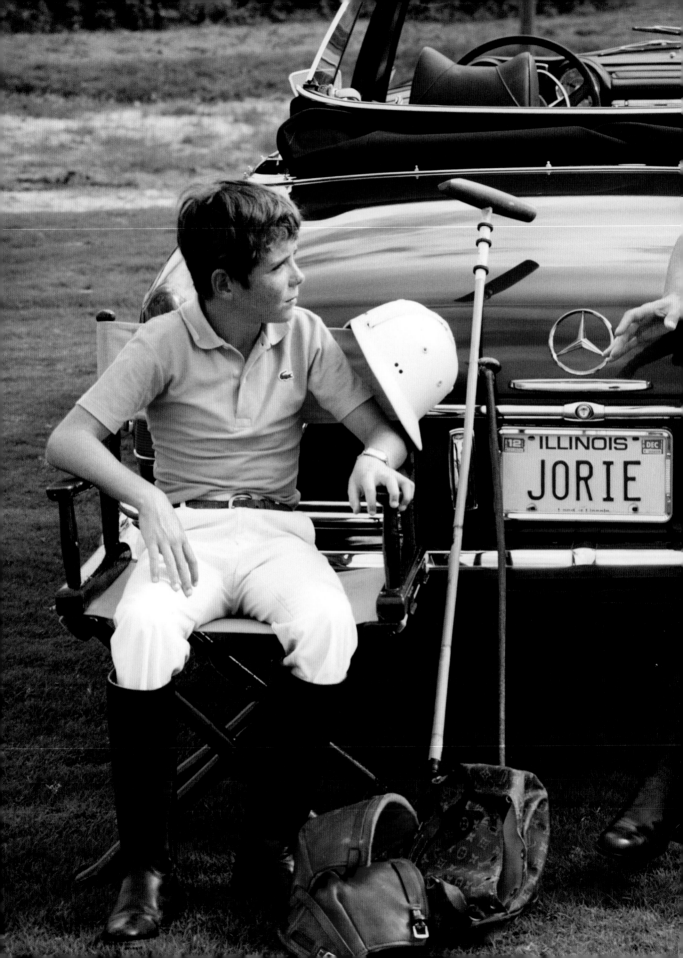

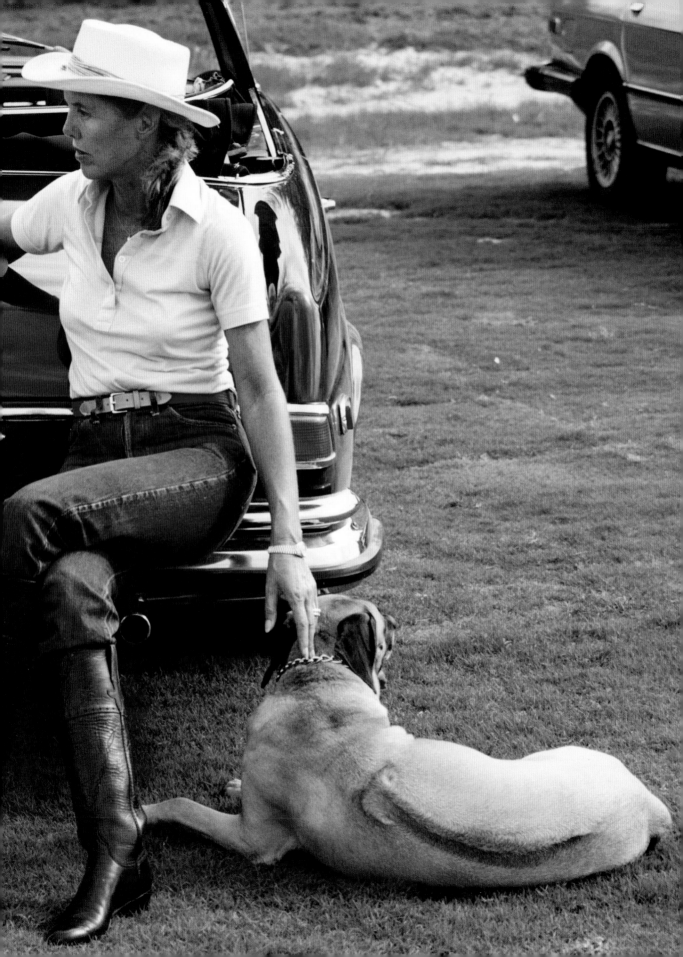

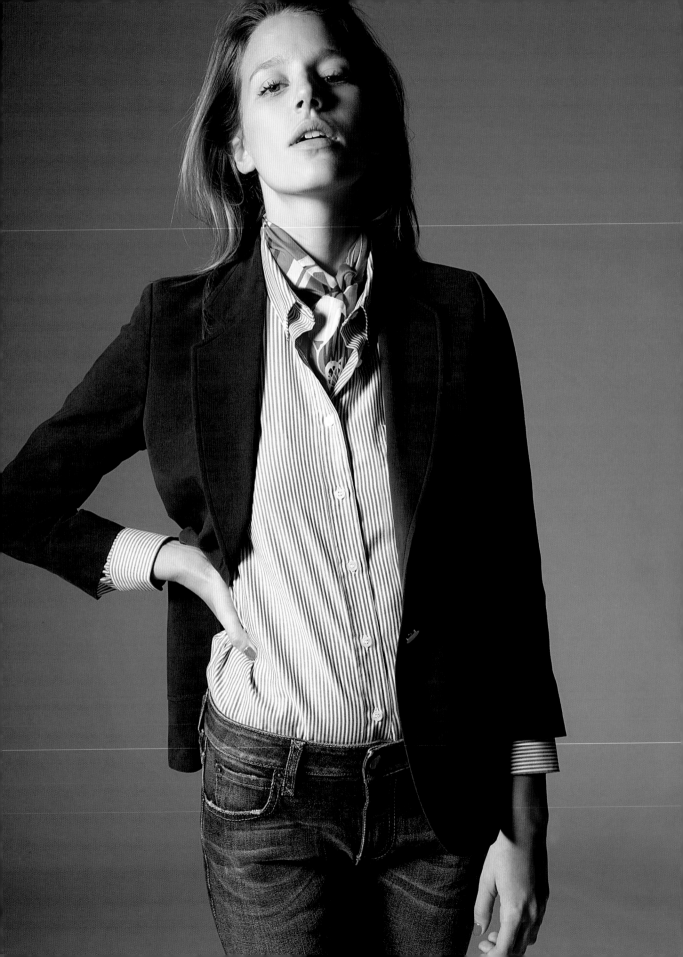

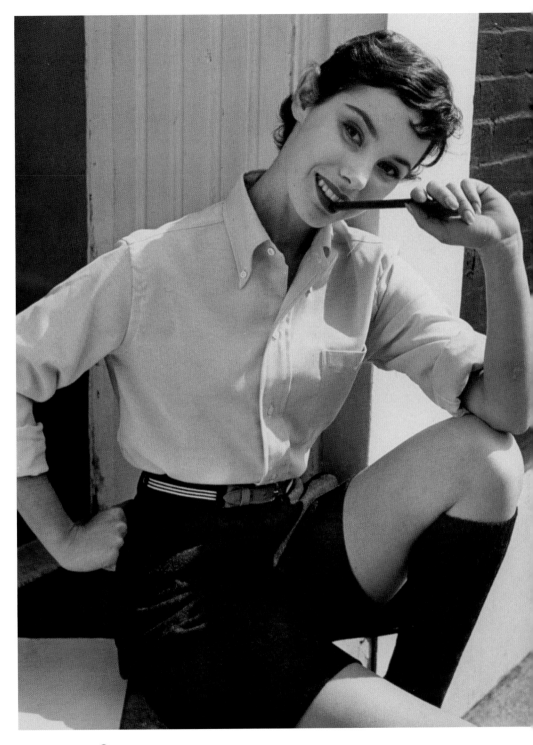

Brooks Sisters

In 1954 Brooks Brothers' New York City store set up a counter "discreetly" in the back of the main floor as a place where women could buy the men's shirts they were already wearing. A *Life* writer commented on the trend: "Given this opening, more and more women have encroached upon the whole store, greedily discovering other items of male apparel that they can take over for themselves."

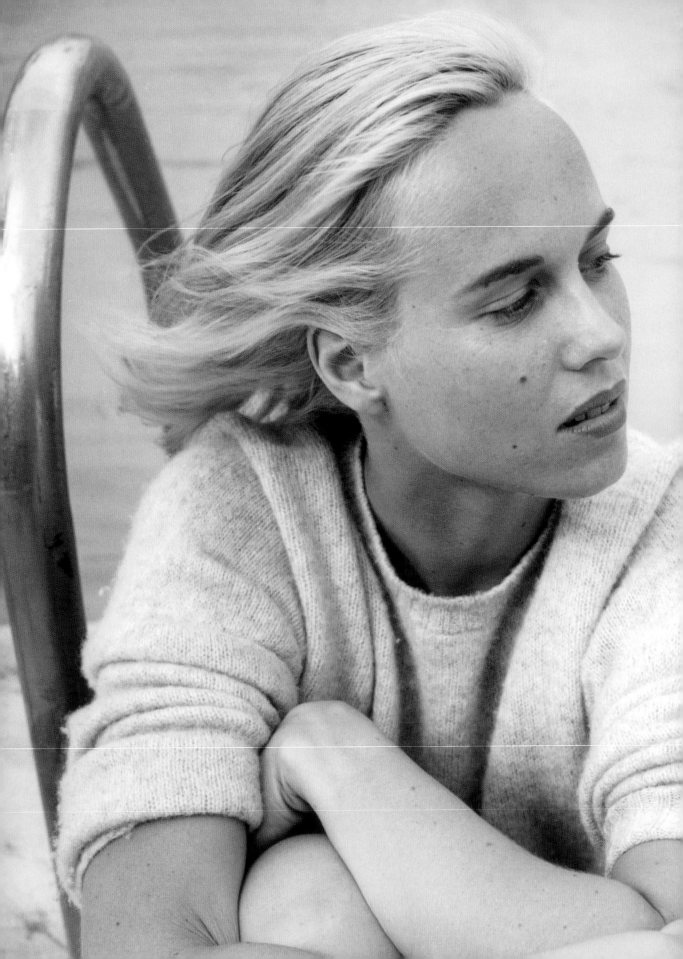

Sporty Socialite

American photographer Slim Aarons photographed Patsy Pulitzer (née Patsy Bartlett) in Palm Beach, Florida for the 1955 issue of *Holiday*. He said she was "quite social and sporty." Pulitzer proves that prep classics, like the crewneck sweater, will always remain timeless.

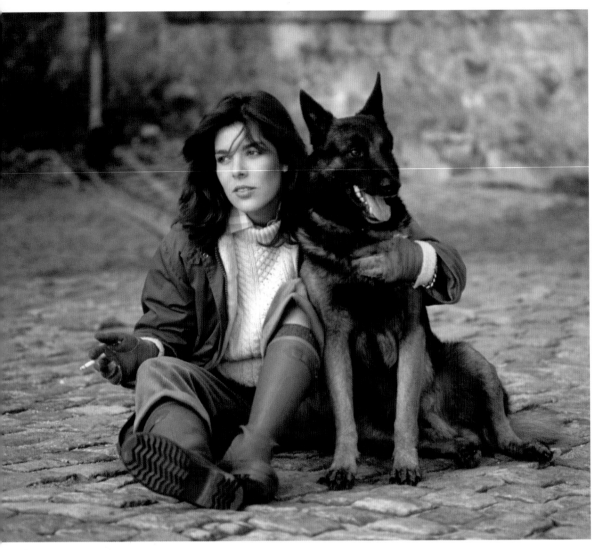

Prep Royal

Princess Caroline of Monaco seamlessly balances royal splendor with a classic prep look in 1982 at the royal Grimaldi family's French Villa with her pet German Shepherd. Presumably the princess was channeling her mother, American actress Grace Kelly, who married her own preppy Philadelphia roots with Monégasque royalty in 1956.

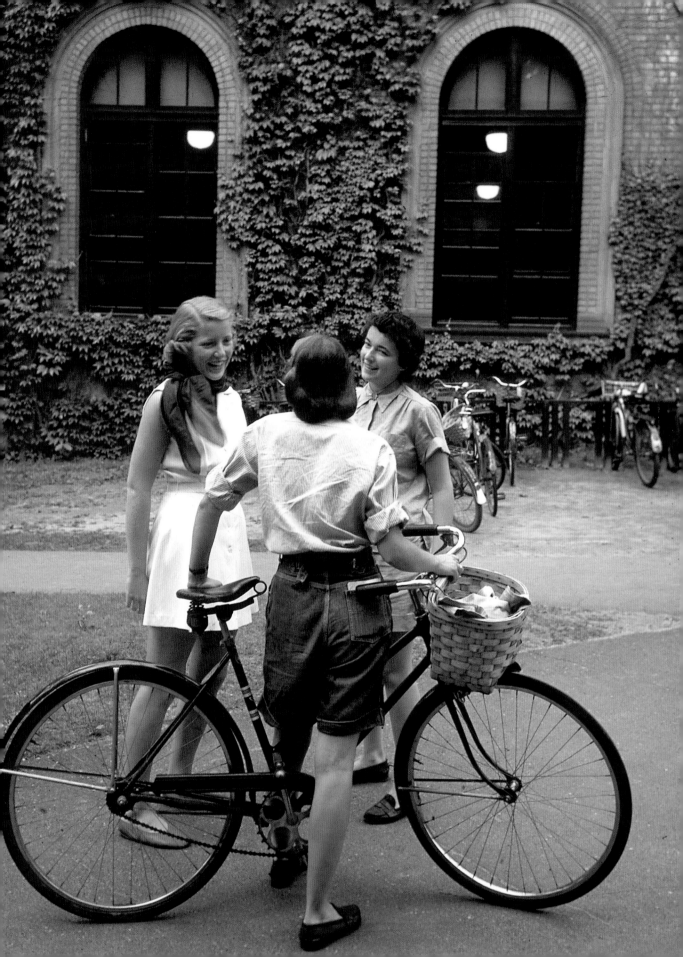

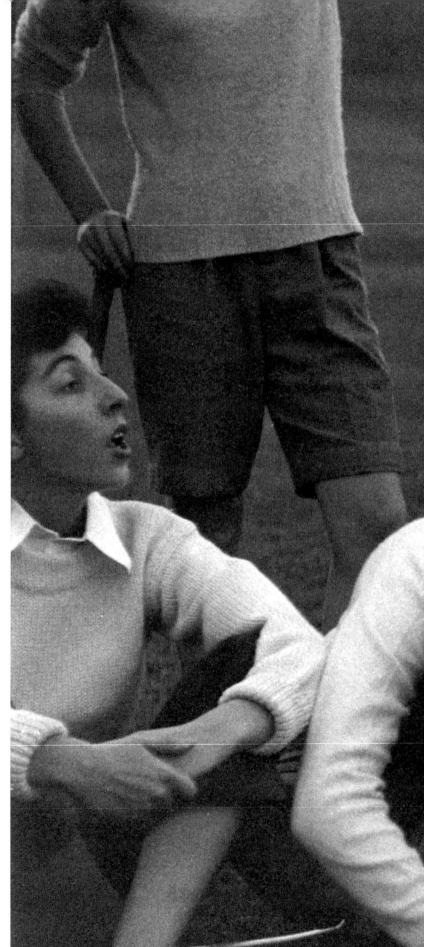

Battle of the Sexes

In 1948 when Sarah Lawrence College
was still a women's school, they took on
the men-only Princeton University in an
exhibition field hockey match. The men
wore frayed skirts over their shorts:
the women didn't. Though the two
schools don't play each other today,
the Princeton field hockey team is still
wearing skirts, and boasts an all-female
roster as well.

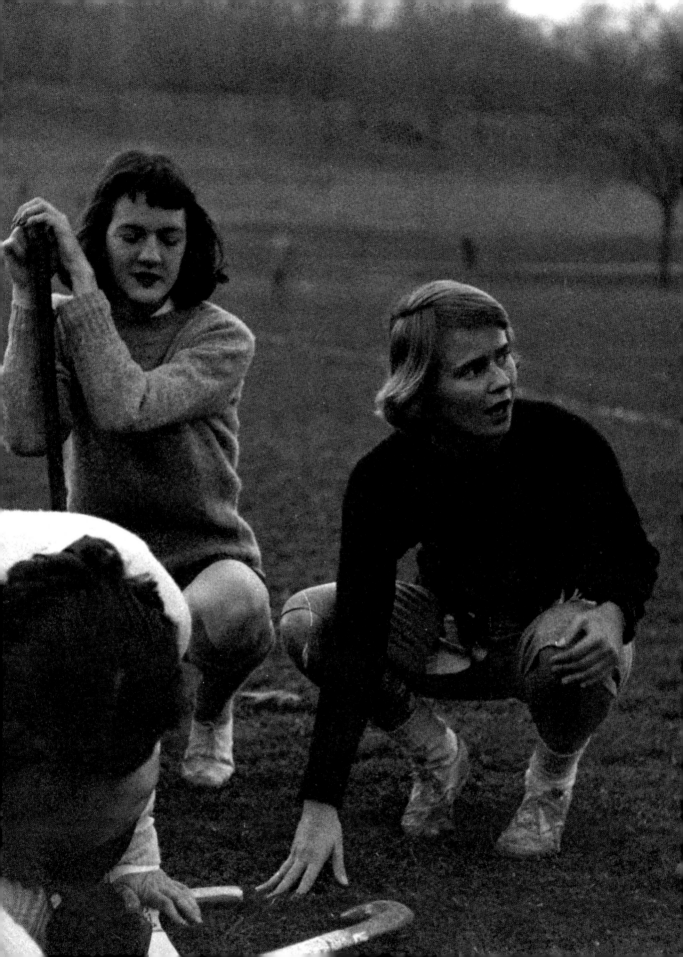

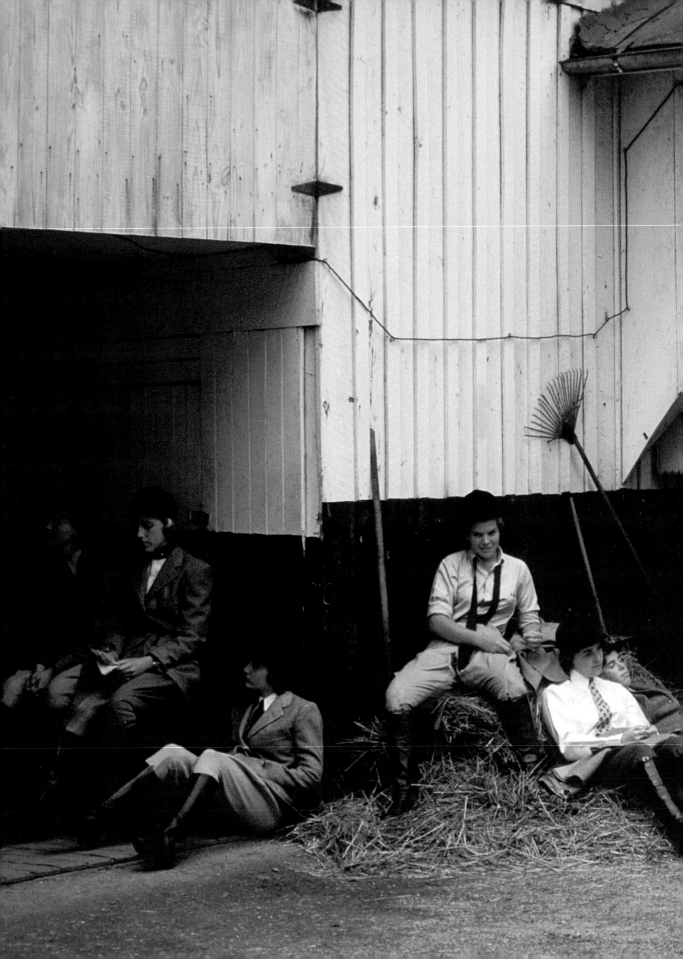

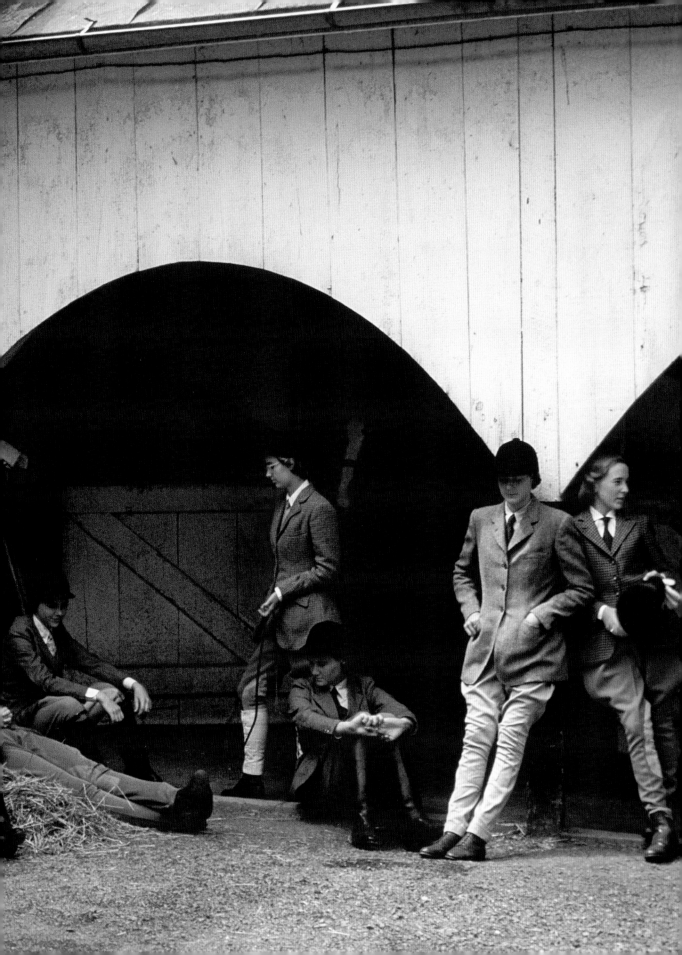

the adventuress

The adventuress is in a class of her own. The aviatrix taking her first transatlantic flight, the war correspondent dodging bullets to report a story, the fisherwoman battling rapids to land a trout, the sailor going solo around Cape Horn—each is inextricably bound to the others by the heart-fluttering drive for excitement. This is the woman who laughs at the weatherman, opting for her motorcycle despite the downpour. She'll happily swap risk for the pleasure of embarking on a daring adventure. The adventuress dresses first and second for function. The true test of whether her outfit works is neither a mirror nor the opinion of an other—her outfit works if it actually works. Getting muddy and collecting scars is part of the fiber that defines the adventuress, and she often considers them part of her outfit.

My first day of fly-fishing in Wyoming was met with great expectation. I laid out my outfit the day before. Polarized sunglasses: check. Straw hat: check. Patagonia fishing vest: check. Waders: check. Sunblock: check. Any adventuress worth her salt will tell you, though, that the adventure begins when the plan falls apart. My most treasured fishing story isn't full of glory or a long battle with a twenty-inch trout, but merely involves surviving a six-hour float down the Snake River in a late September storm. My hands were numb under wool fingerless gloves, my knees blue, and the majestic Tetons stayed huddled behind the clouds. As the rain soaked through our clothes and filled our waders, we kept rowing and casting, rowing and casting, rowing and casting. When I rested, I focused on the side of the boat, watching it move along the river in silence, to mentally verify that inch by inch we were moving toward heat and shelter, still several hours away. Instead of a gourmet picnic lunch with a checkered tablecloth, we each ate a soggy sandwich standing under our own pine tree listening to thunder overhead. We realized then that we were the only boat on the river; we had a National Park to ourselves. We witnessed a pocket of nature in the same silence and beautiful isolation as Lewis and Clark may have, slinking by completely unnoticed by a thirsty bull moose and a bald eagle perched on a Douglas fir. The tooth-chattering misery soon gave way to awe, and then to laughter as we came to terms with how terrifically we had misjudged our day. I caught my first trout that day, my only fish over the span of six hours, but the satisfaction of feeling dry heat pumping through the vents of a '94 Ford Explorer and recounting our adventure has yet to be trumped.

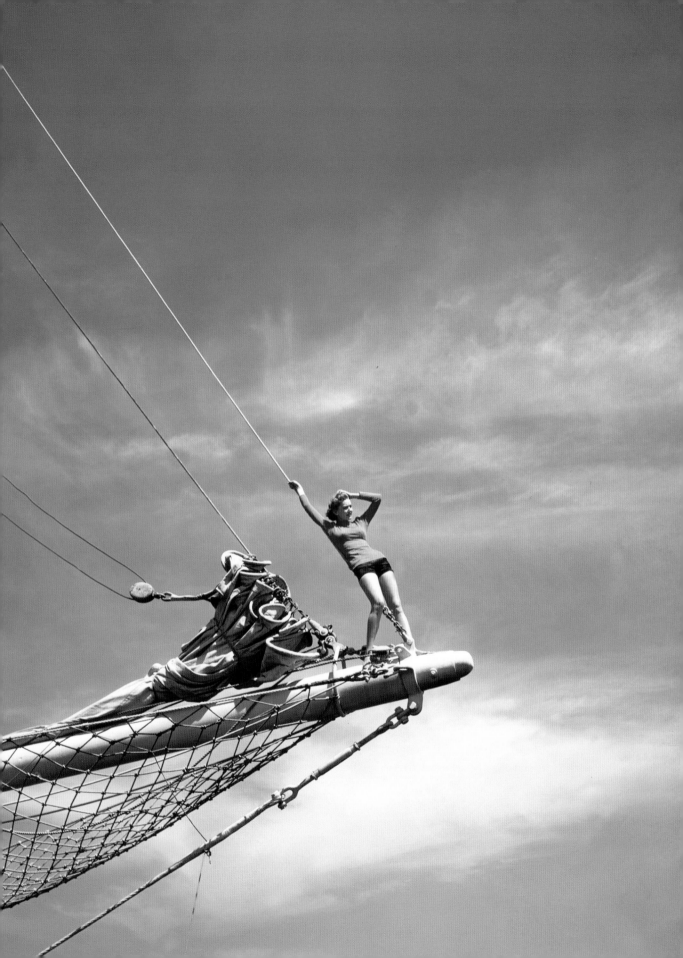

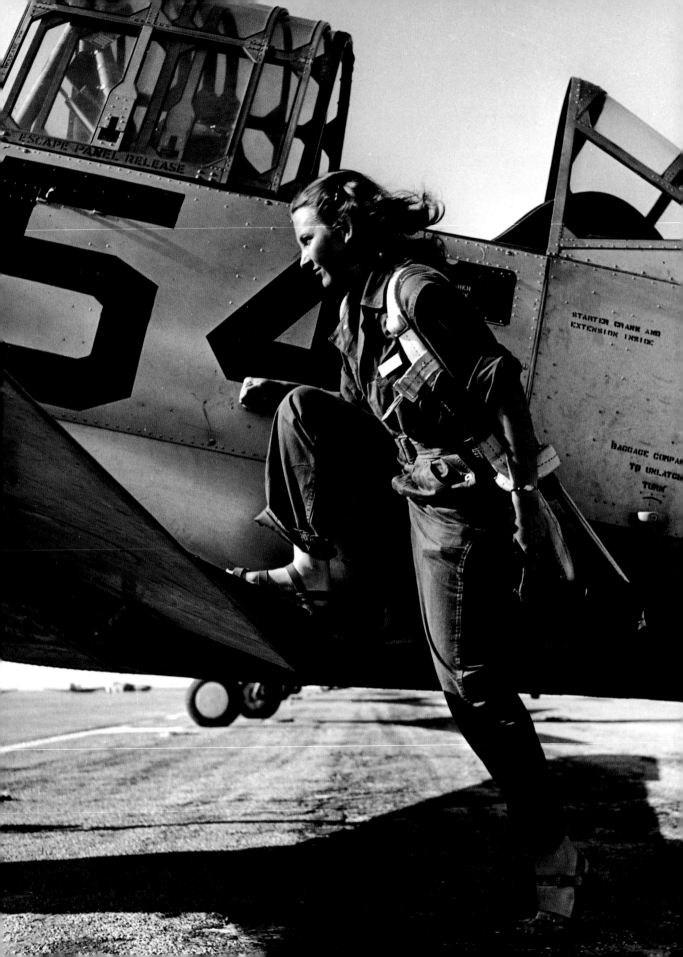

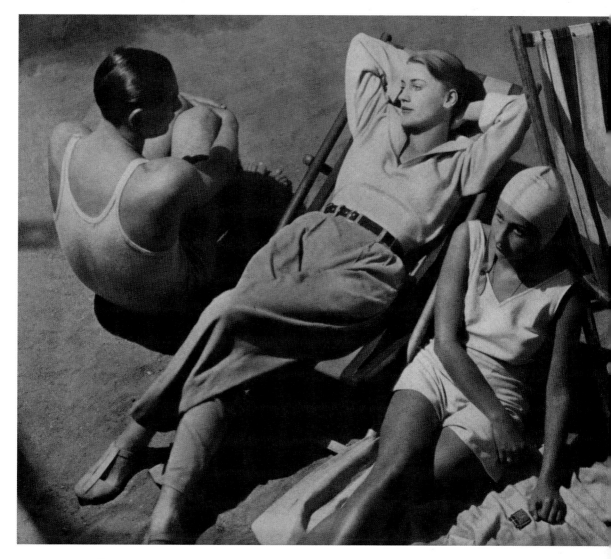

Battle Star

"Model turned war correspondent" isn't a common phrase, but Lee Miller indeed made the leap and became one of World War II's most revered photojournalists. She covered the London Blitz, the liberation of Paris, and the concentration camps for *Vogue*. Memorably she was photographed nude in Hitler's bathtub. A year after the war ended Miller told a radio interviewer: "Naturally I took pictures. What's a girl supposed to do when a battle lands in her lap?"

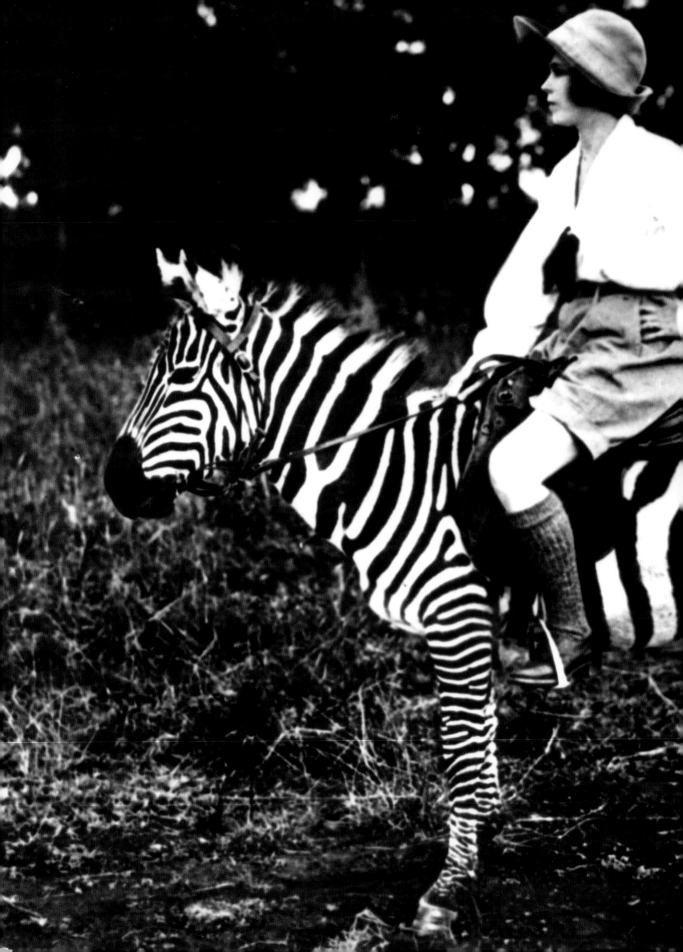

Mrs. Adventure

Osa Johnson, a native Kansan, literally wrote the book on adventure. Her 1940 autobiography, *I Married Adventure*, chronicled her exotic travels around the globe with her husband, Martin. In the early twentieth century, the Johnsons explored Africa and the South Pacific, where Osa handled rifles with the same ease as her camera, and rode zebras with the same skill as she flew seaplanes, one of which was boarded by a wild gibbon.

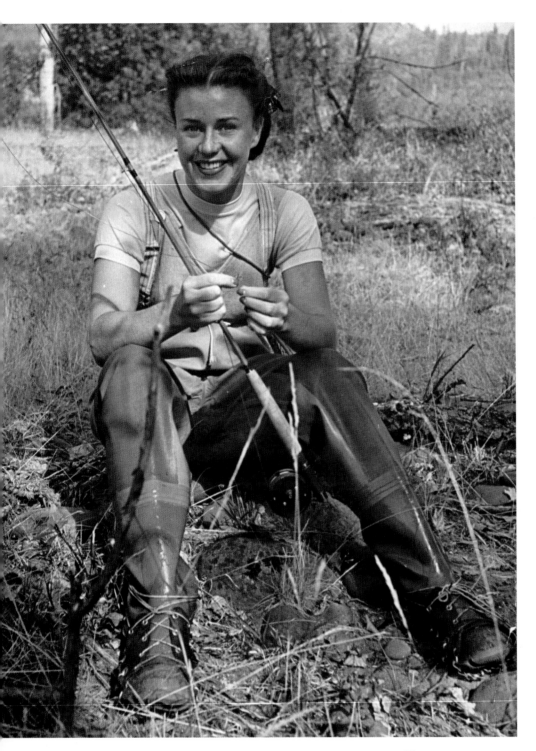

River Dance

Ginger Rogers would drive fifteen hours north from Hollywood to get some good country air and honest living for a break from her profession of dancing and acting. Rogers owned a ranch that spanned more than a thousand acres of Oregon's Rogue River Valley. There she tended pigs and cows, fly-fished, and cooked and canned her own food.

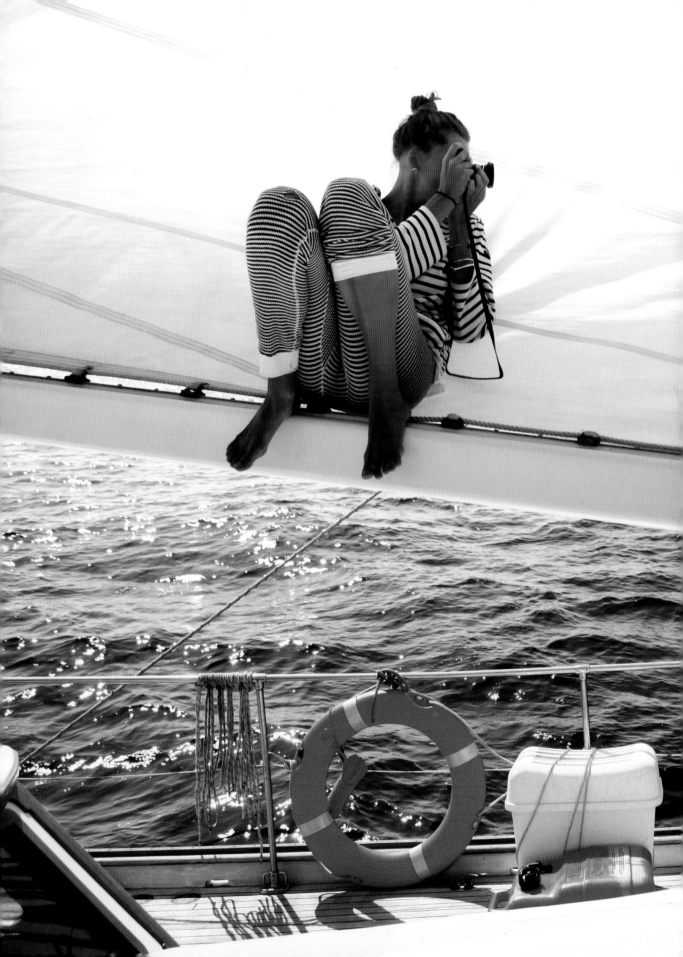

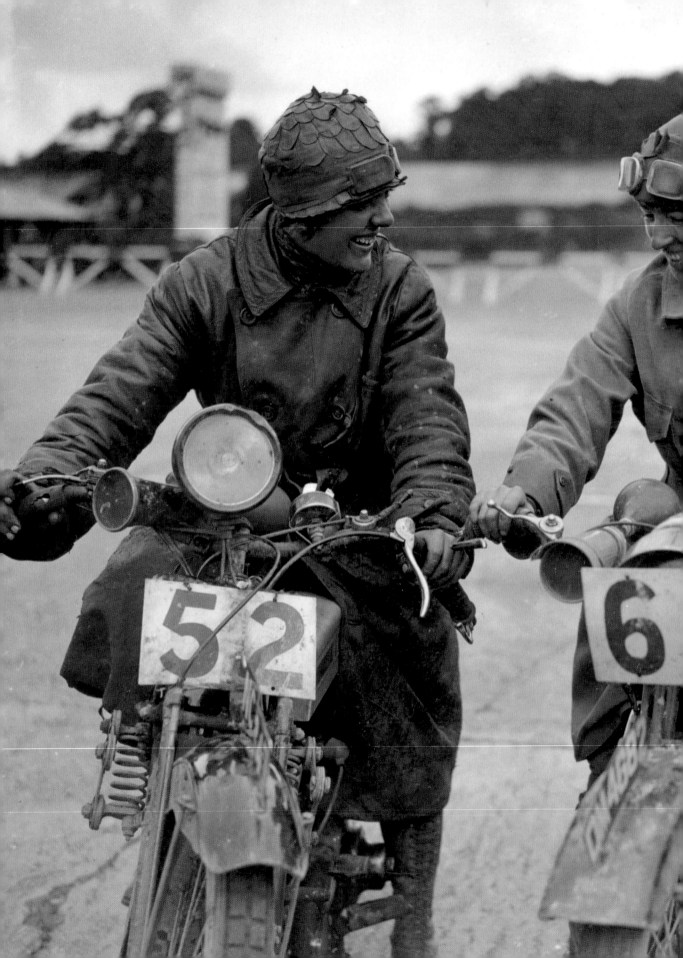

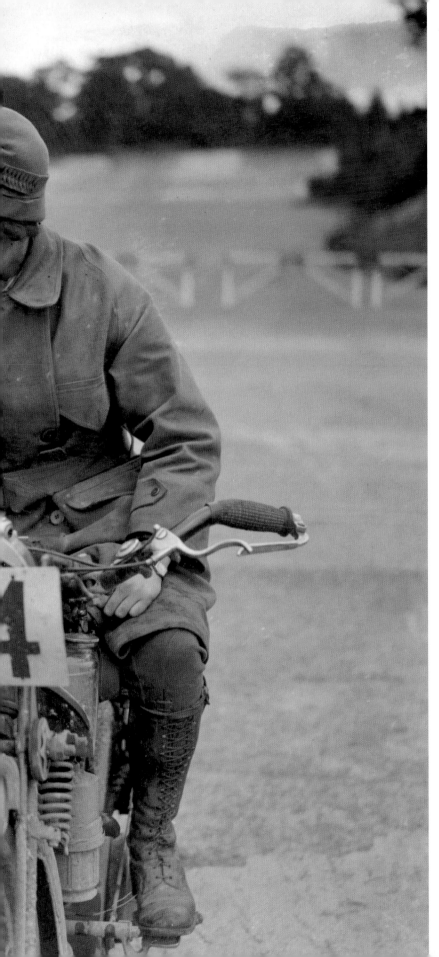

Motor Queens

Miss E. Foley and Miss L. Ball entered their motorcycles at the International Six Days Reliability Trials at Brooklands race track in 1925. These races were meant to test the machinery as well as the endurance of the riders and their equipment on rough roads with poorly marked routes. To finish, riders needed to be self-sufficient, adept at navigation and mechanics, and to value adventure well above safety and comfort.

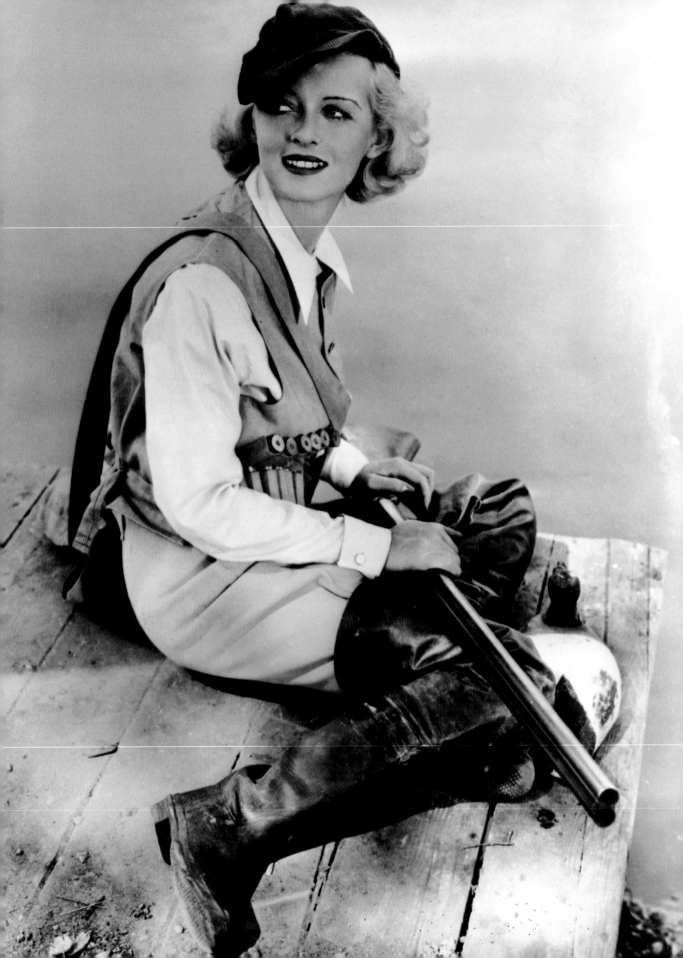

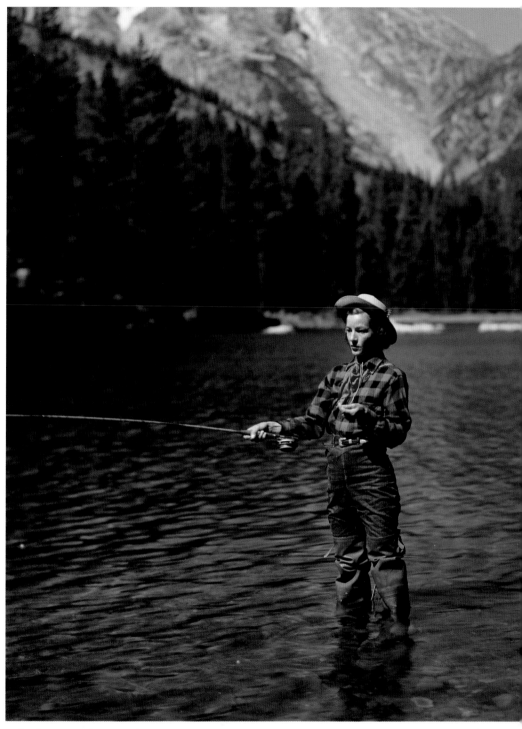

Teton Temptress

The Snake River at Jackson, Wyoming has barely changed since men and women began fishing it for trout during the westward expansion. Waders and rods aside, fishing the Snake is about being in harmony with nature, and trusting your instincts. Mud, rain, slime, and bugs are just some of the unpicturesque elements that a fly-fisherwoman must not only combat but enjoy in order to fully embrace the glory of the Snake.

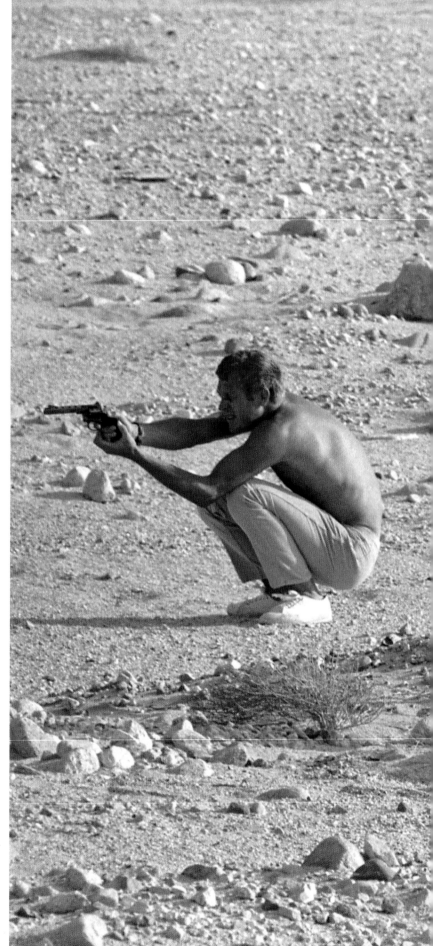

Rock Steady

Before Steve McQueen proposed to Neile Adams, he fell in love with her on a motorcycle. She remembered, "We went on a weekend drive, after a show I was in at the time. We were on a motorcycle, and there was a carload of friends behind us. It was freezing ass cold. We stopped for a bite to eat, and one of the guys said, 'Steve, why don't you let Neile ride with us? I can ride with you. It's too cold.' And I said, 'No, I think I'm just gonna stay on the bike.' Steve told me later, 'That's the moment I fell in love with you.' "

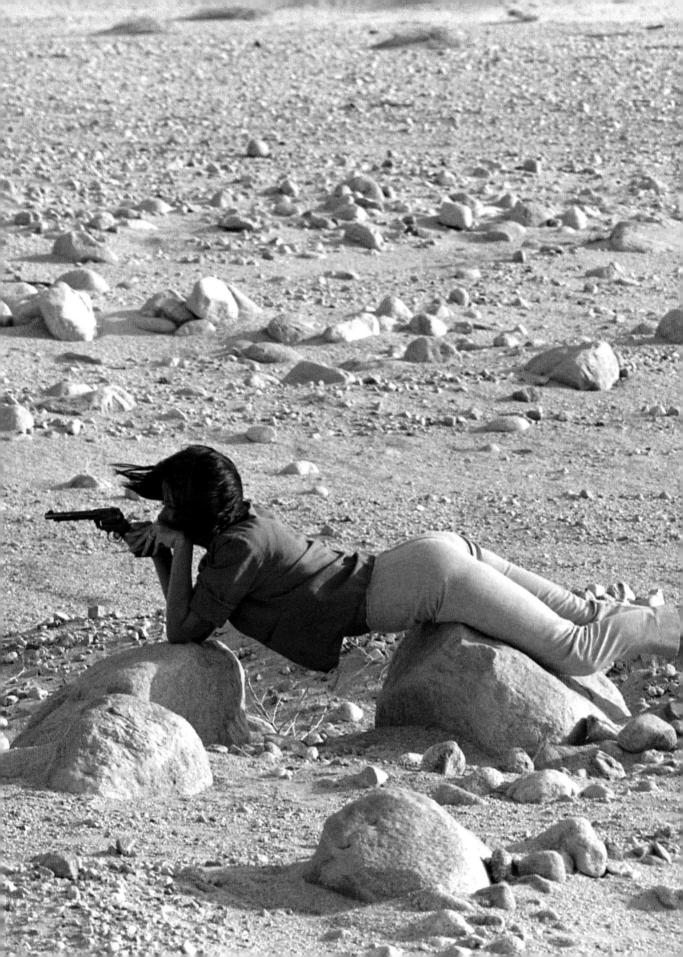

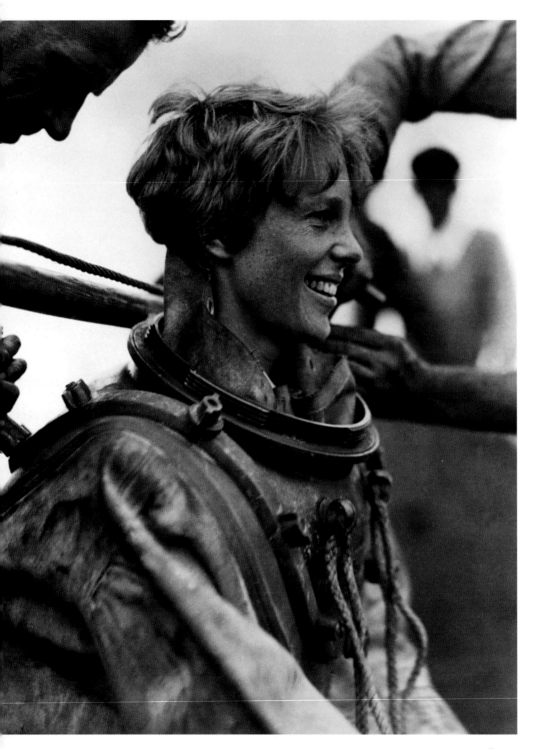

By Air and by Sea

Amelia Earhart, the country's most beloved aviatrix, explored beyond terra firma not only in the skies, but also in the sea. While deep-sea diving was still in its infancy, Earhart dove off the coast of Block Island in 1929. A *New York Times* writer wrote that she lost her nerve and was frightened under the headline MISS EARHART BALKS. As a response, the very next day Earhart dove for twelve minutes in twenty-five feet of water.

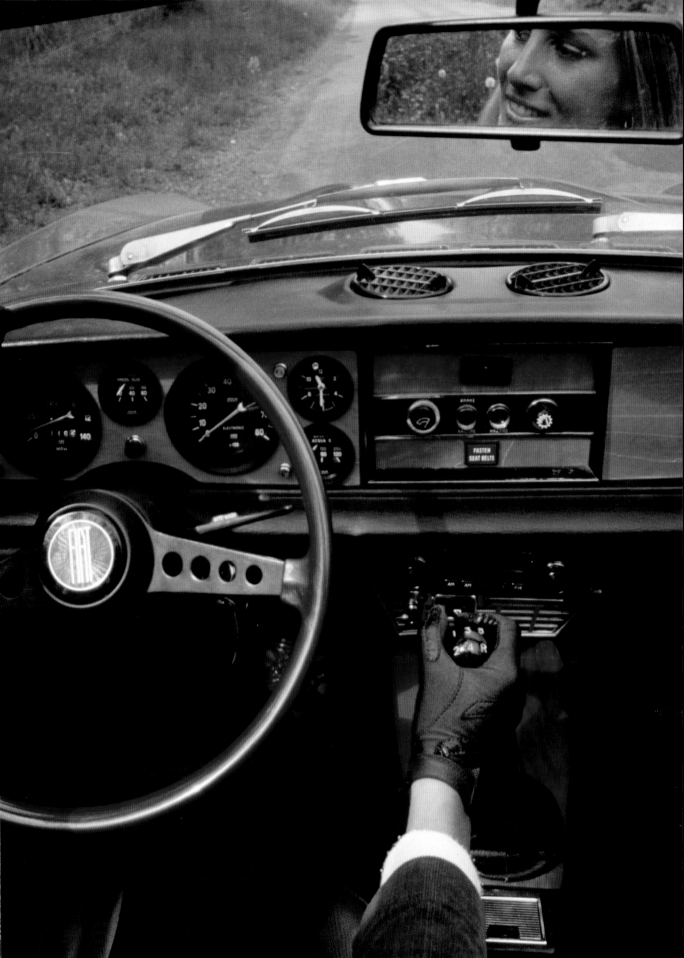

the girl next door

As a girl she wore ripped Levi's, pedaled a fire-engine red Schwinn, and roamed American neighborhoods on late summer nights. As a woman, she channels this barefoot Huck Finn spirit with a wardrobe of T-shirts and shorts, jeans and sneakers. She is the kind of girl that does handstands in pools, climbs trees, washes her car in the driveway, and eats grilled cheese with tomato soup. The girl next door has been defined and redefined onscreen, from Mary Anne Summers of *Gilligan's Island* to Mary Jane Watson of *Spider-Man*. She is innocent yet mischievous, a love interest and a best friend. Outwardly she projects a wholesome familiarity; within her gaze lies a mysterious femininity.

My husband grew up a few miles from me in a tree-lined neighborhood outside of Chicago. While I didn't quite live in the house next to his, or even on a shared street, we were close enough to both hear the same train roll up the Milwaukee District North Line late at night as we fell asleep. The deep locomotive echoes forever connect us in a shared childhood experience, a comforting familiarity in lives that have taken us all over the world. I have faded memories of riding my red bike down his driveway and looking up into his bedroom window, but I'll always have a clear reminder of our budding romance from the chugging sound of a freight train.

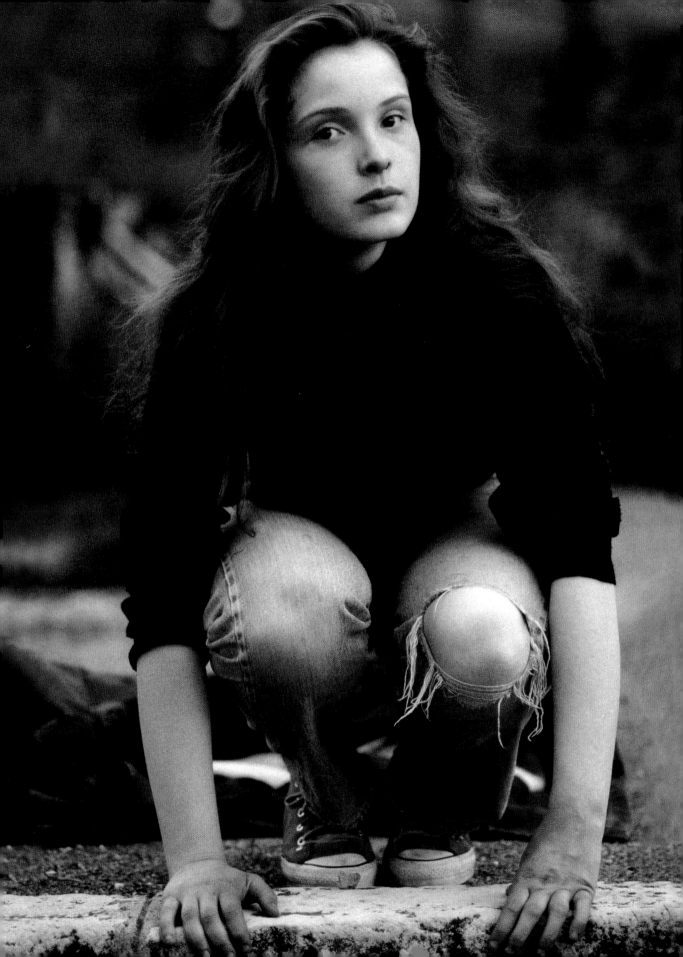

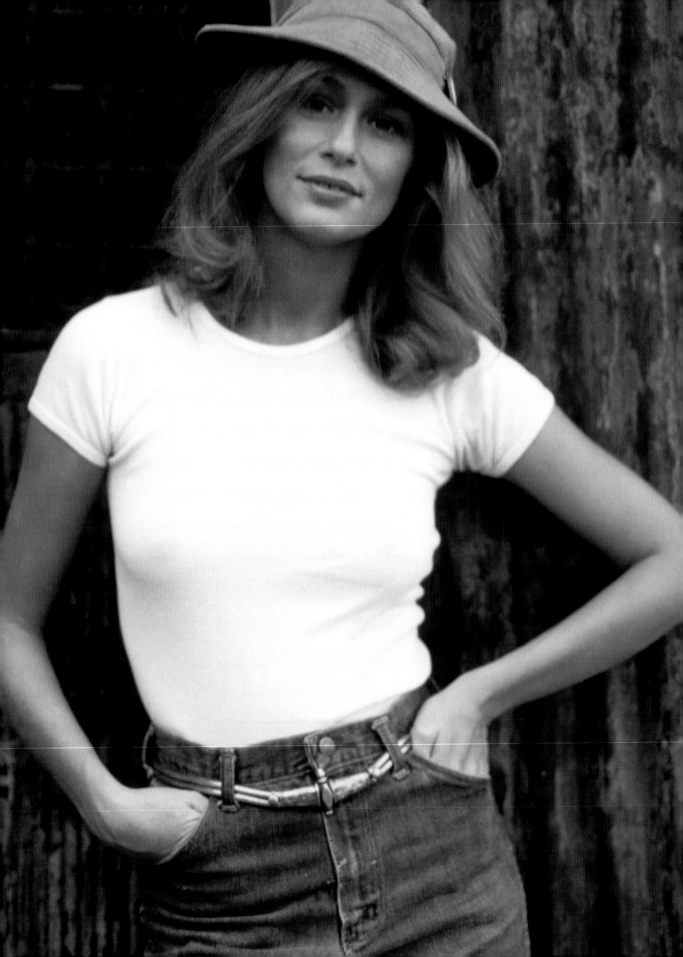

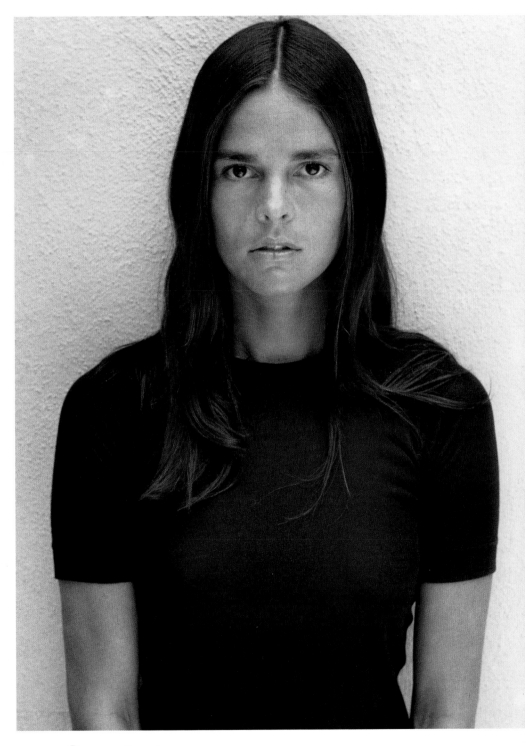

The Real McCoy

Ali MacGraw played a range of tomboys onscreen from the sporty tennis-playing Brenda Patimkin in *Goodbye, Columbus* to the tough-as-nails Radcliffe student Jennifer Cavallari in *Love Story*, and Carol McCoy, the gun-toting bank robber in *The Getaway*. Surely her tomboy spirit and style is just as present offscreen.

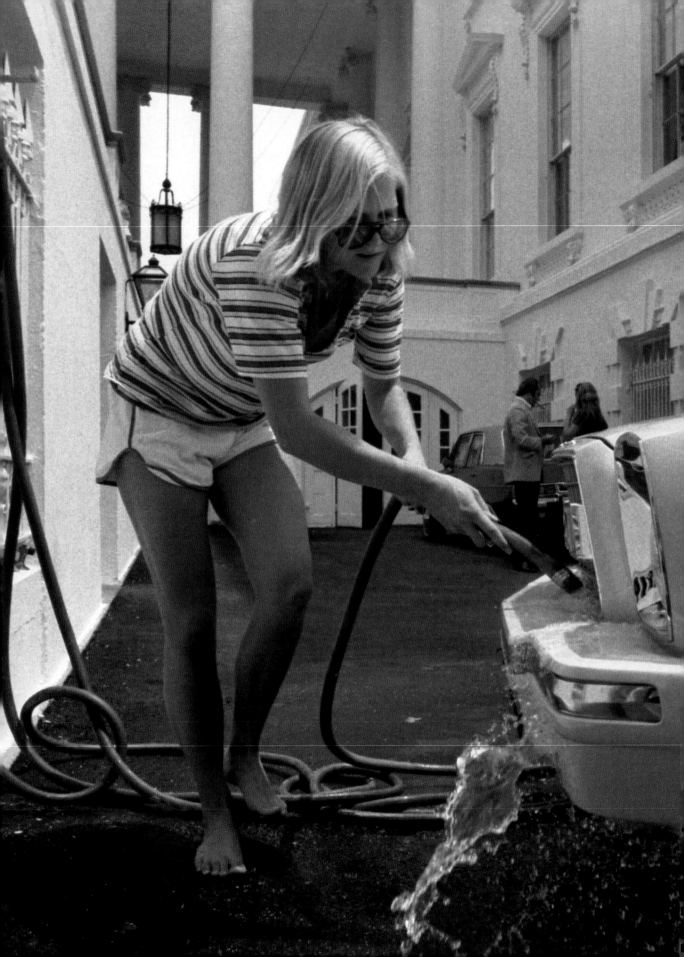

White House Wash

Susan Ford was one of just a handful of high-school-aged kids to ever live in the White House. She held her senior prom in the East Room and washed her car in the driveway of 1600 Pennsylvania Avenue. The youngest of an athletic and outgoing family, Ford kept up with three older brothers, whether on the tennis courts of Camp David or the ski slopes in Vail.

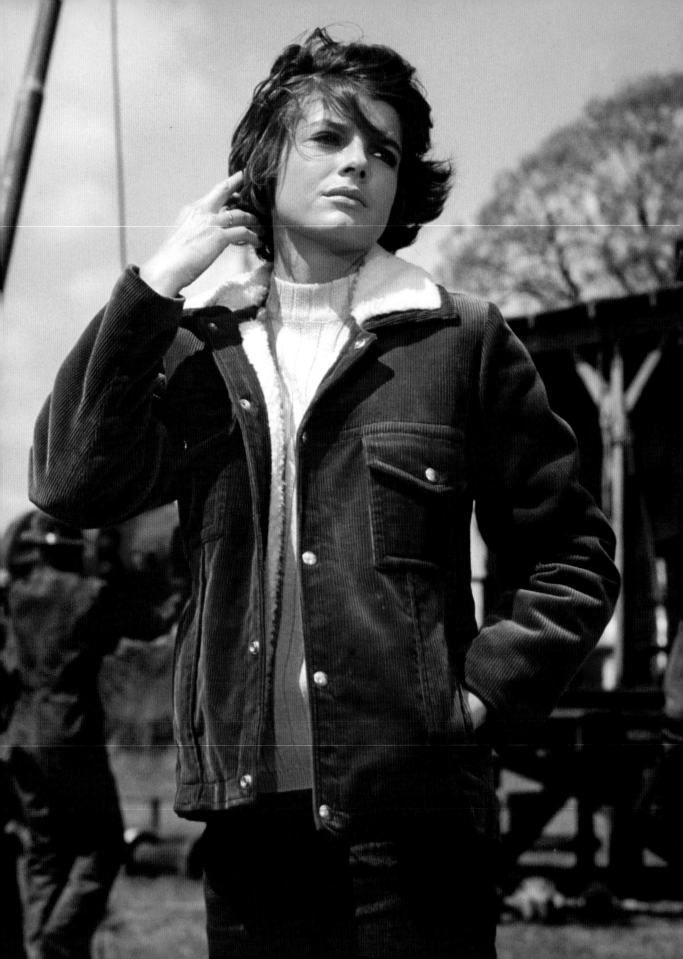

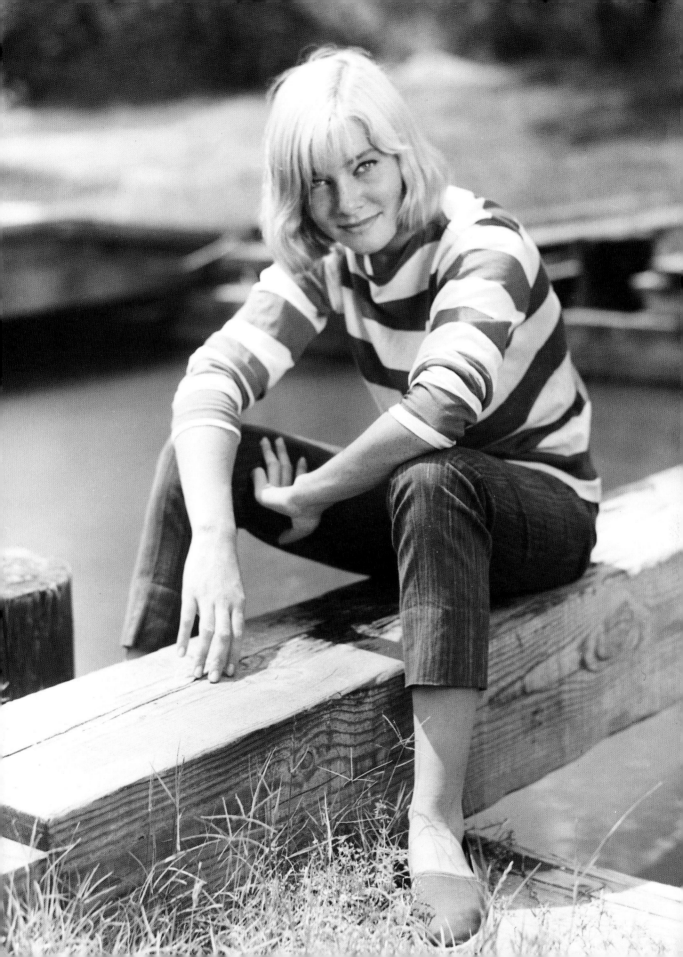

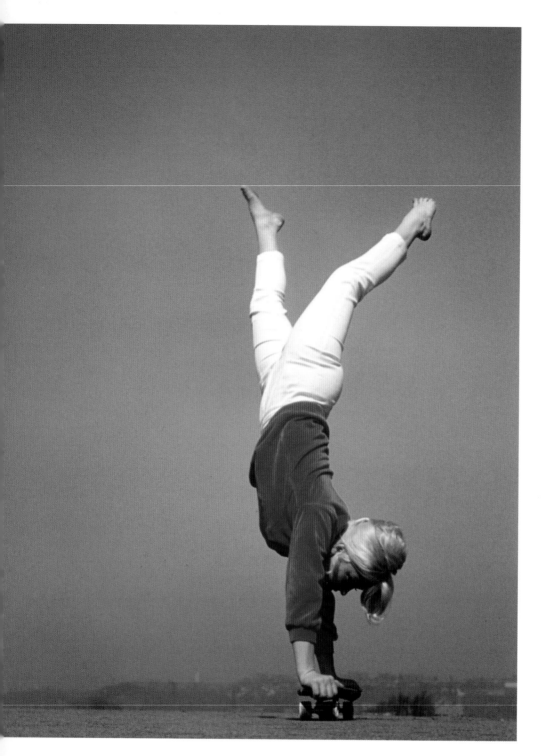

The Original Betty

Patti McGee was the first female professional skateboarder and the first women's national skateboard champion. Sponsored by Hobie, she helped popularize skating all over the country at the peak of the sport's first craze. She is still an "old-school" skate icon today, immortalized as the *Life* magazine cover girl that hit the stands on May 15, 1965.

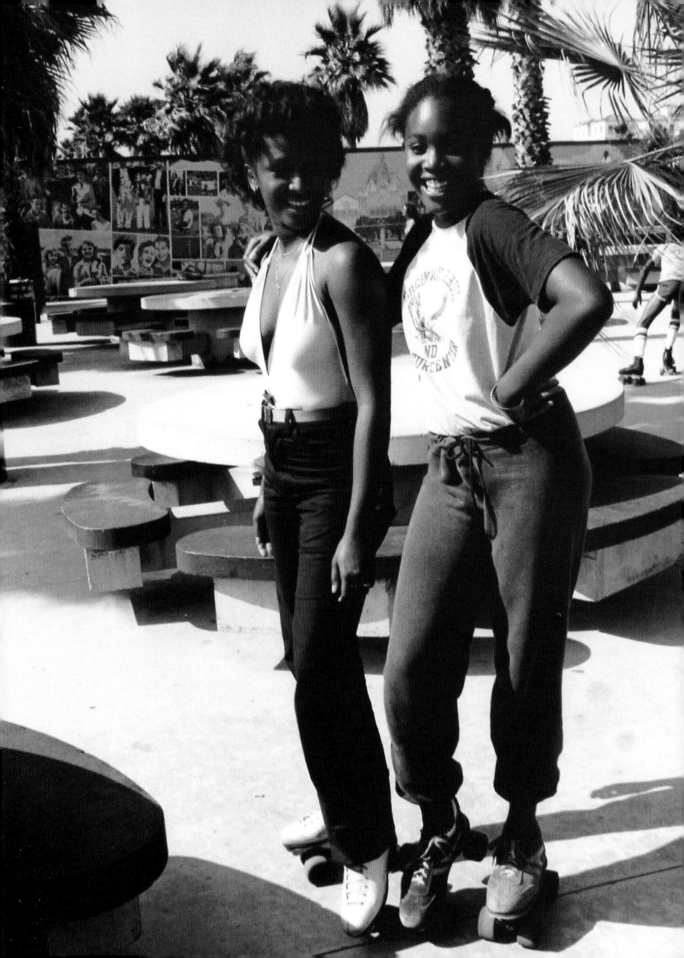

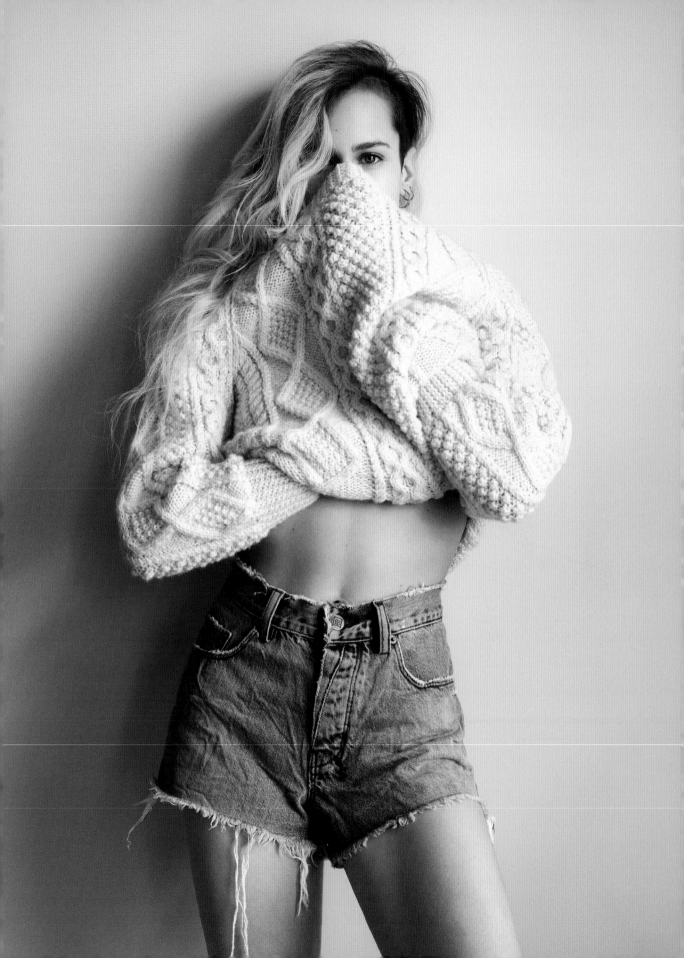

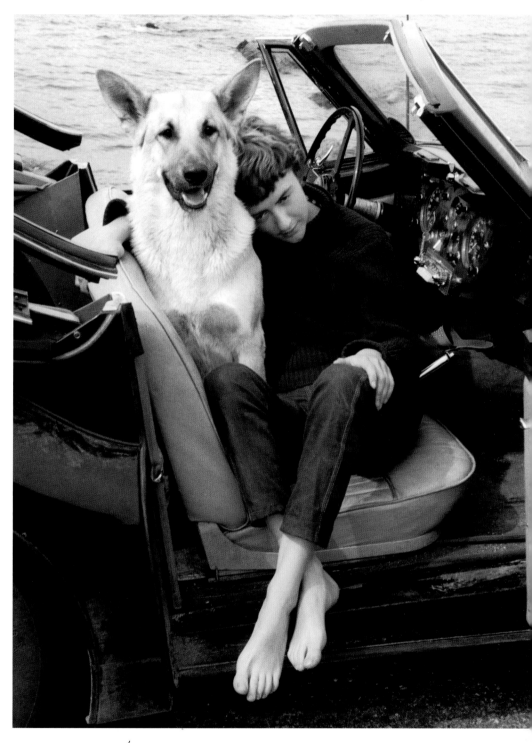

The Fast Lane

Prolific and existential playwright Françoise Sagan loved to drive. She drove Aston Martins and Jaguars, often to go gambling, often fast. In her book *Avec mon meilleur souvenir*, she wrote, "Speed is no sign, no proof, no provocation, no challenge, but rather a surge of happiness."

Mountain Girl

While still high school-aged Mariel Hemingway earned an Academy Award nomination for her role in Woody Allen's *Manhattan*, but it was under the big skies of Idaho that Hemingway grew up skiing and hiking. She recounted, "The beauty of the Sawtooth Range was a comforting gift to me. When I could drive—and country kids in Idaho drive at the age of fourteen—I would head off alone to places where the steep hills came right down near the road. I climbed dusty trails and boulder-filled avalanche chutes up to the high places."

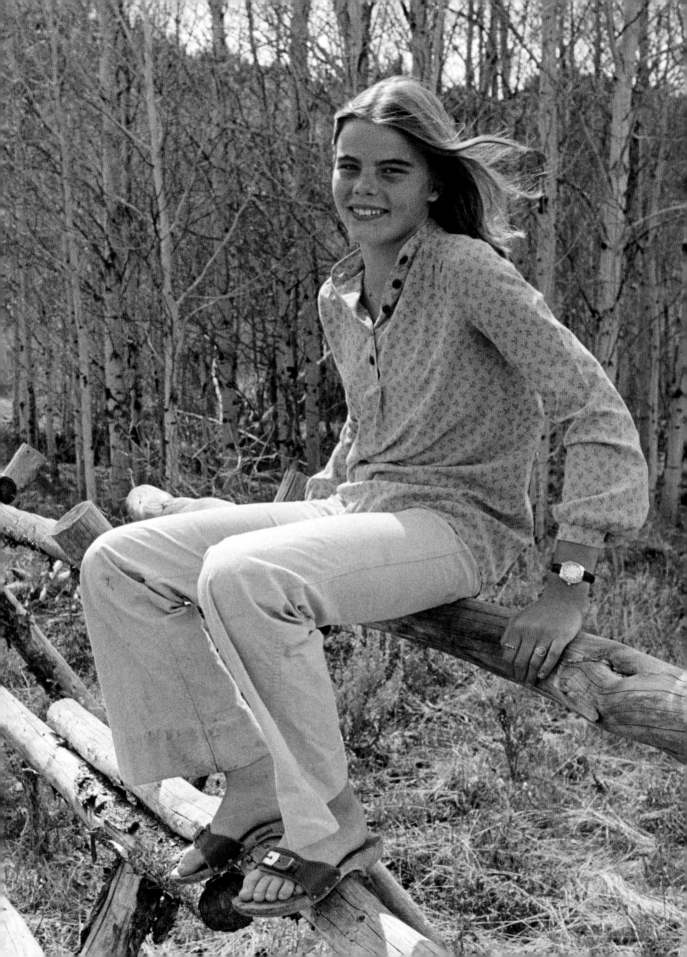

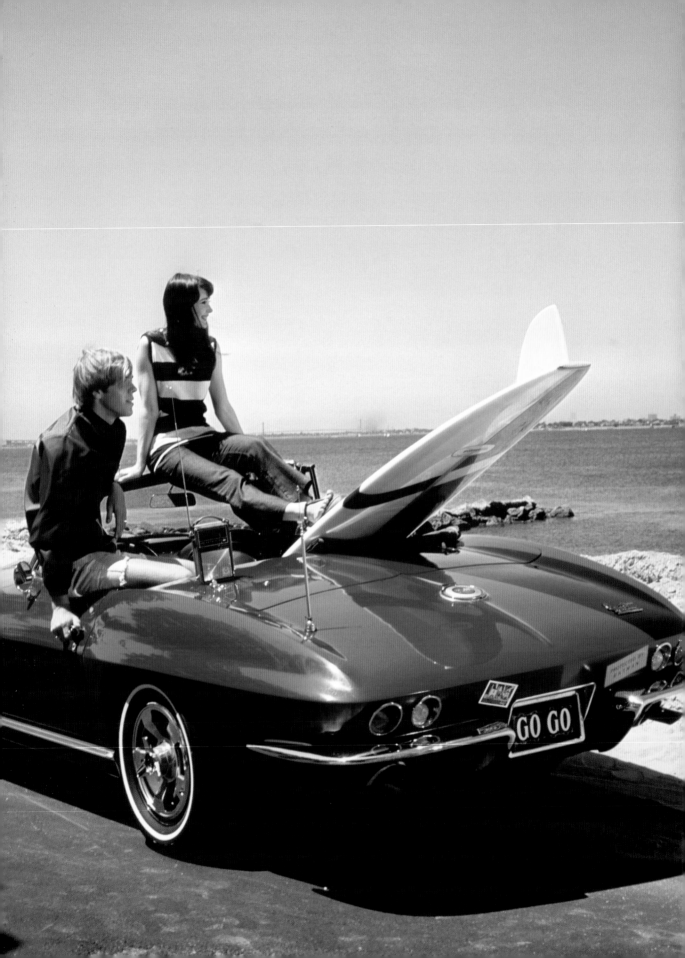

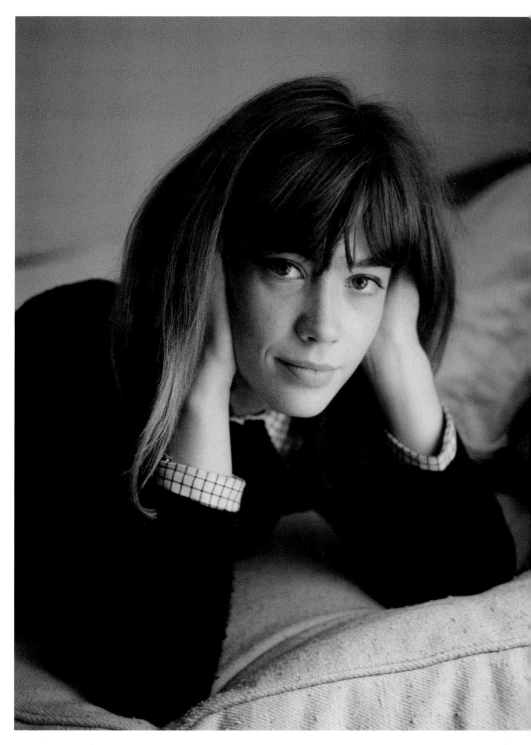

Hardy Style

French singer Françoise Hardy's style has inspired contemporary tomboy
icons like Alexa Chung as well as couture designers like Nicolas Ghesquière
of Balenciaga. What is striking about Hardy is her undeniable sexiness
paired with a buttoned-up conservative aesthetic, a true fashion rarity.

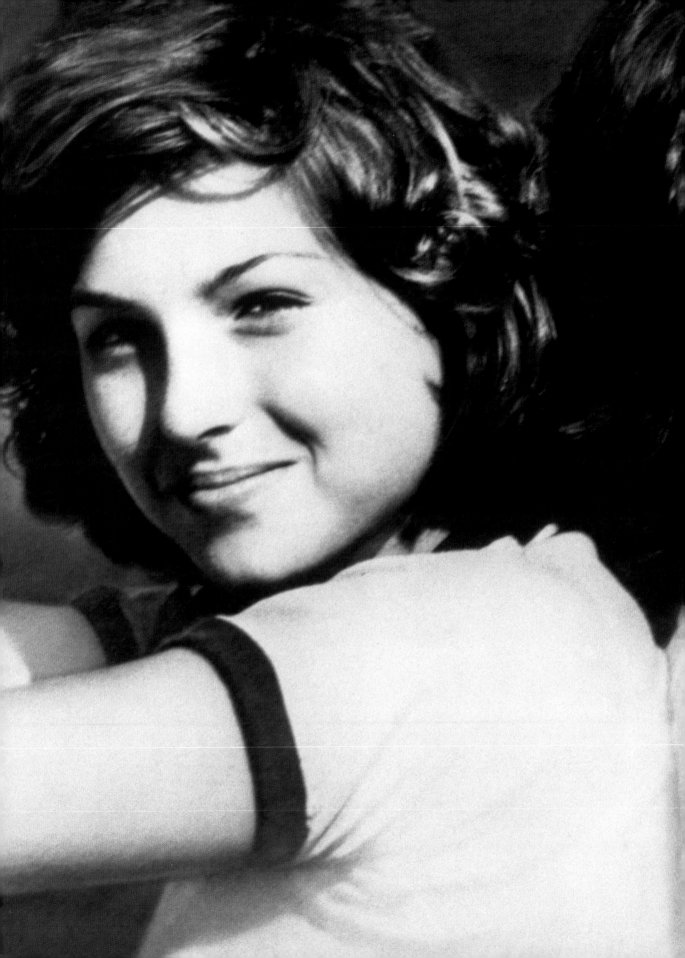

Little Darlings

Tatum O'Neal and Kristy McNichol both masterfully brought the tomboy character to life on the screen, from O'Neal's roles in *Bad News Bears* and *Paper Moon* to McNichol's role as Letitia "Buddy" Lawrence in TV's smash hit *Family*. Still, many people think of their onscreen performance together in the 1980 film *Little Darlings* as the apex of twentieth-century tomboy.

the natural ist

The naturalist is more comfortable outside than in. She sees a field of black-eyed Susans as a place to nap, a herding dog as a lifelong companion, and trees as ladders. Her hair is windblown like the sand dunes she hikes over. Her feet are hardened and her toes never painted, just like the unpaved country roads she walks. And like her surroundings, this is the kind of woman who dresses seamlessly to function in the great outdoors. She is minimal, she is free, she is natural. Her skin is sun-kissed, her spirit is untamed, her beauty as old as the Earth.

My mother let her hair turn a beautiful steel gray and her smile lines deepen without intervention. She's also a fresh-air addict. Barely can she handle more than two consecutive days with the windows sealed. On some of the hottest, most humid nights of summer, my brother and I slept above our sheets in utter disbelief. "Fresh air is good for you," she'd say as we glared back. She always gave great praise to natural beauty, whether it was a savannah stream or a woman's appearance. Unsurprisingly I was never taught how to apply makeup. At slumber parties girls would get giddy about glosses, liners, straighteners, and blush. I stood silently behind an invisible wall, nodding, trying not to let on that I felt like a foreigner who didn't speak the language. My inability to curl my eyelashes trapped me with embarrassment and insecurity then, but today it is a freedom I happily exercise. I wear makeup sparingly, and can adapt to a day's changing schedule quickly and without barriers. I can be out of the house for a morning hike just as fast as for a last-minute lunch meeting downtown. My mother may not have shown me how to apply makeup, but she taught me to be comfortable in my own skin.

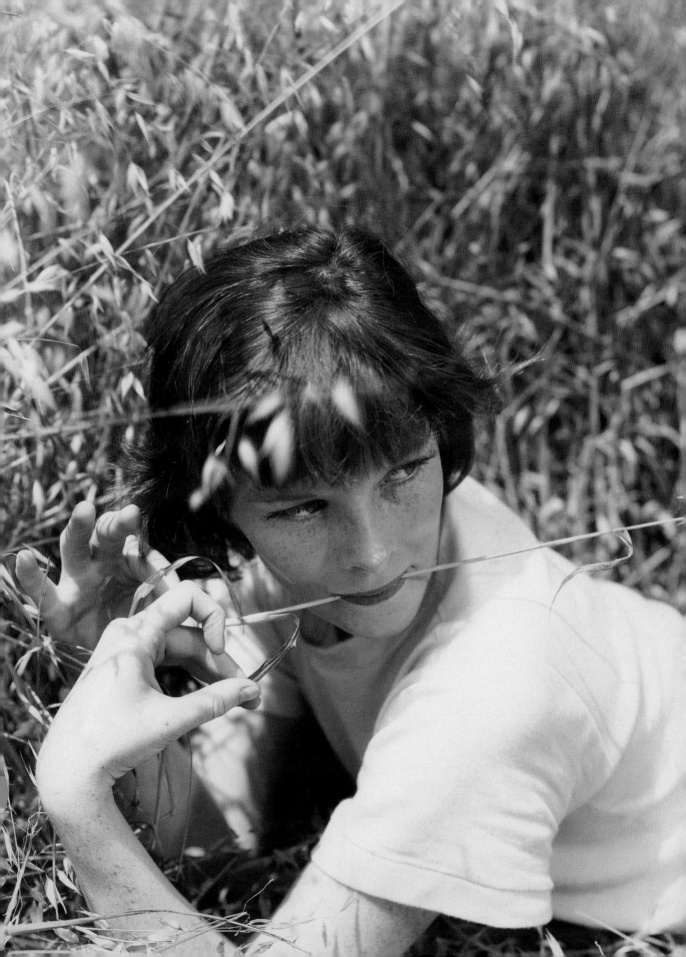

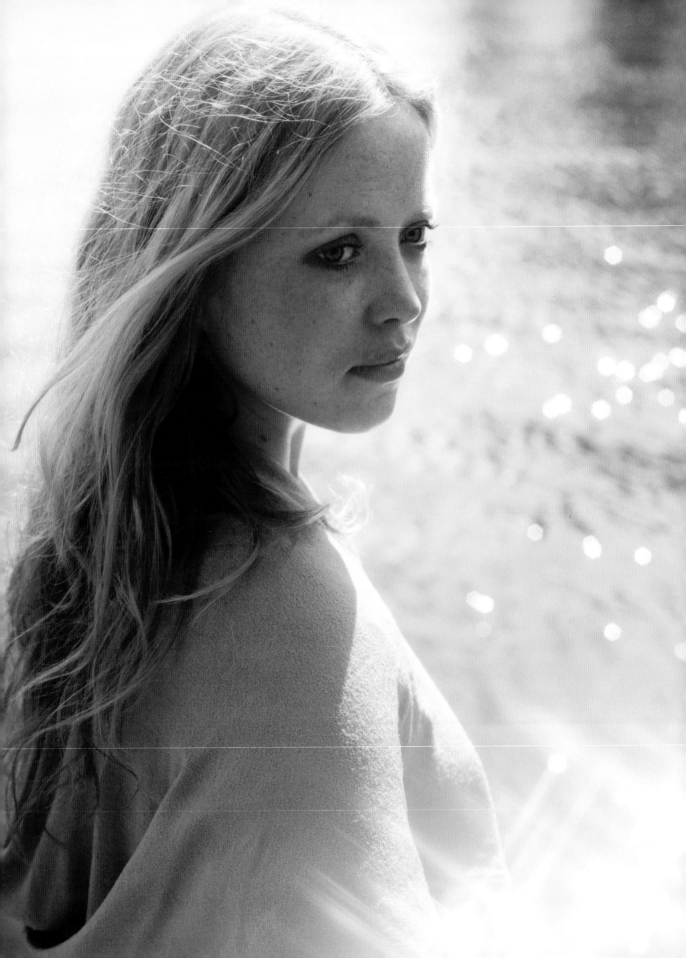

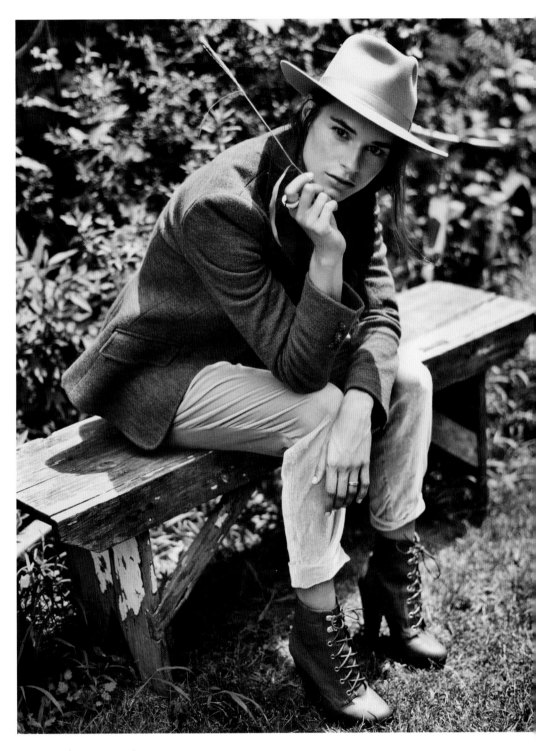

Gaucho Girl

Marina Muñoz is originally from Argentina but grew up living everywhere from the rural splendor of the Berkshire Mountains to the cosmopolitan confines of Mexico City. She's a darling of the New York City street style community, but if Muñoz could spend all day outdoors she would be galloping through the Pampas of Argentina and roaming the fields while drinking maté with her pup, Moreno.

Handsome Heroine

Tilda Swinton is the twenty-first century icon of androgyny. The mix of masculinity and femininity has followed her from childhood, as she remembers the court uniforms of her military officer father. "I remember more about his black patent, gold livery, scarlet-striped legs, and medal ribbons than I do of my mother's evening dresses," she says. "I would rather be handsome, as he is, for an hour than pretty for a week."

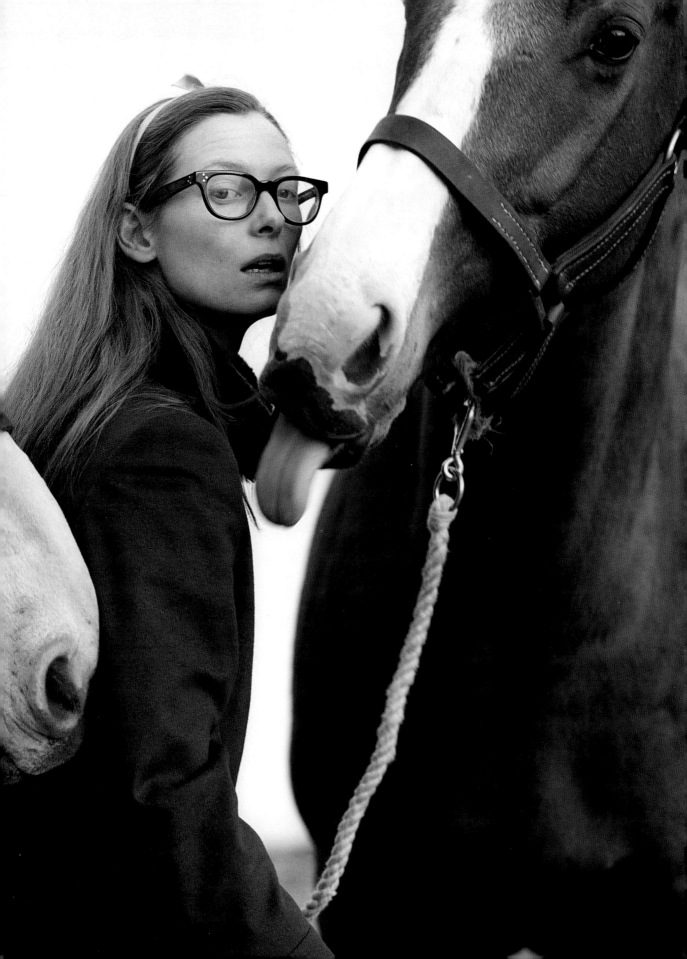

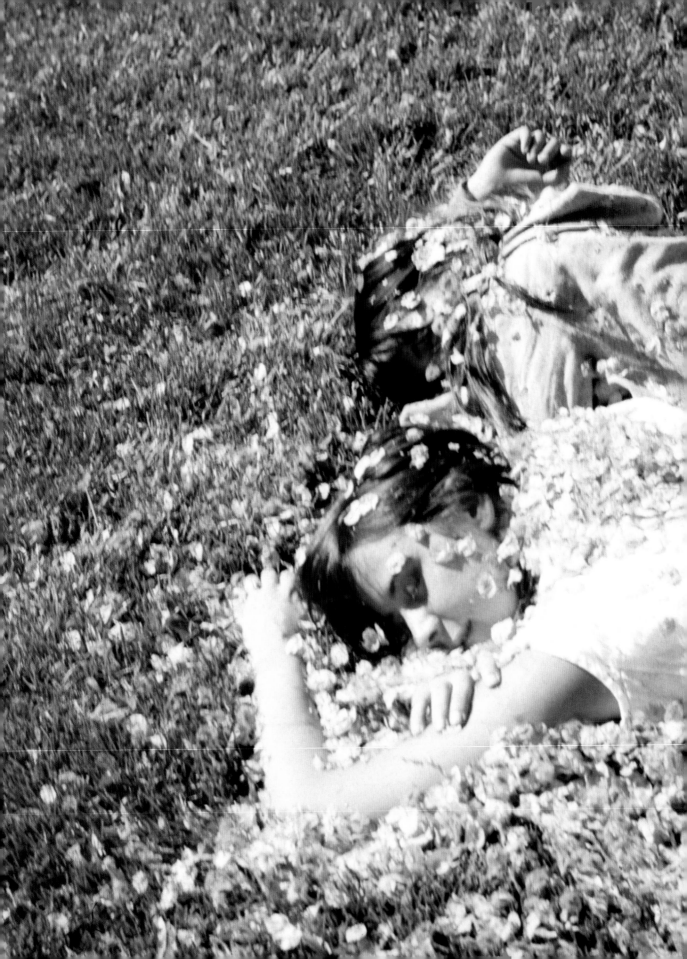

Summer Spell

One of life's great rites of passages consists of laying in the grass in the height of summer, napping to the hypnotic sounds of faraway insects. With eyes closed, memories of the day file through the mind with images of bicycles, swimming pools, popsicles, and tree forts. The evening seems as far away as autumn.

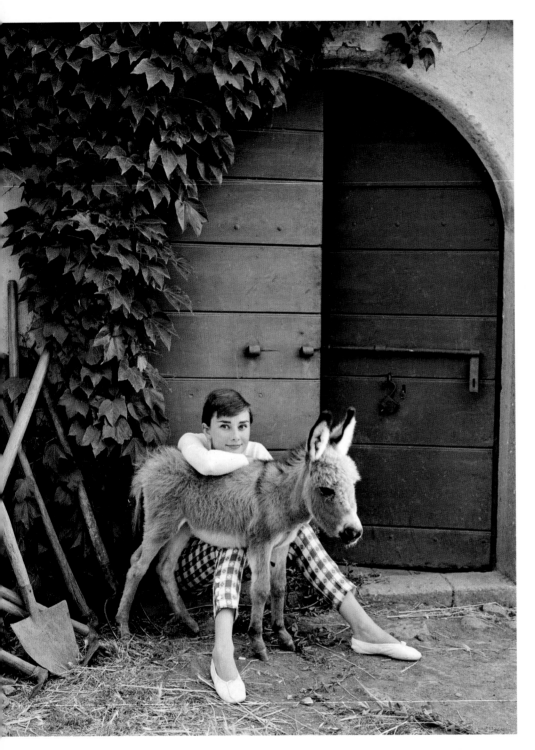

Boyish Charms

Audrey Hepburn's petite frame, pixie haircut, and penchant for sailor pants carved out a look that became synonymous with her name. Her sex appeal showed in her attitude and obvious self-confidence. She cleverly pointed out, "I know I have more sex appeal on the tip of my nose than many women in their entire bodies. It doesn't stand out a mile, but it's there."

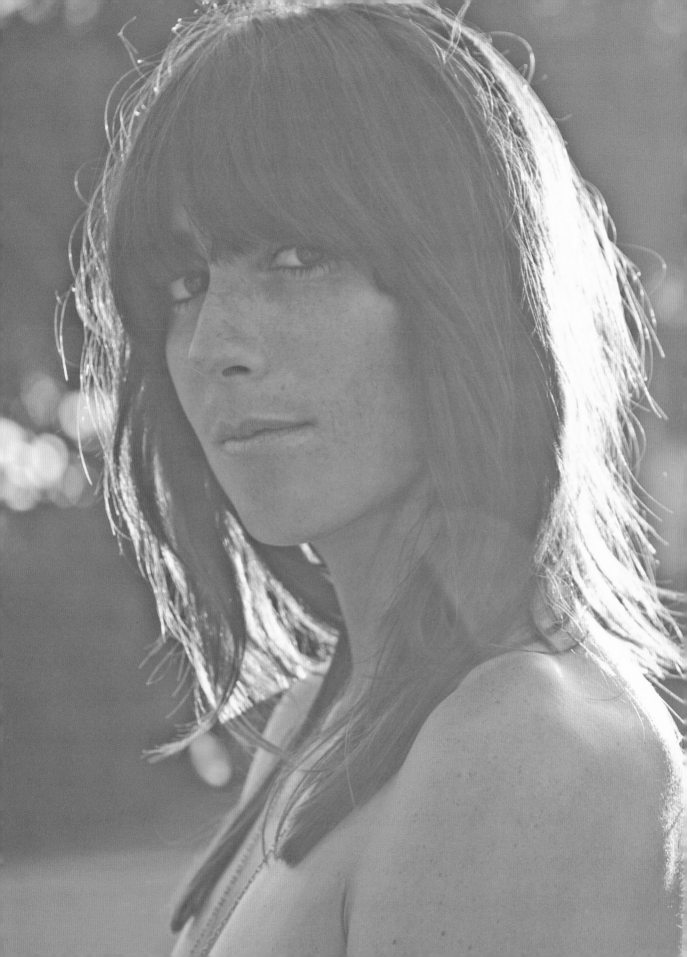

Tomboy Bombshell

Brigitte Bardot may be best known for her bombshell body and her popularization of the bikini, but she had a notable tomboy streak as well, evident in many of her outfits in the 1960s and in her adventurous expressions. Before she turned forty, Bardot retired from acting, modeling, and singing to focus on crusading for animal welfare. In the 1980s she auctioned off much of her jewelry for the cause and has traveled the world promoting the ethical treatment of animals, including at her home in the French countryside where she has raised sheep, horses, and donkeys.

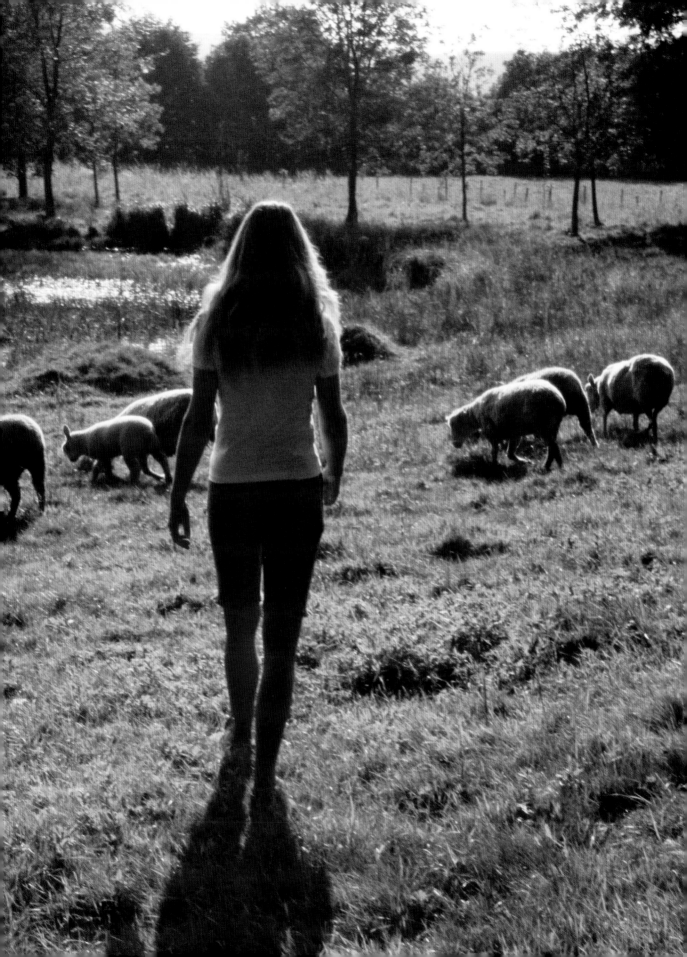

Popperfoto/Getty Images; pp. 62–63: Eartha Kitt in 1952 © Time & Life Pictures/Getty Images. Caption credit: LIFE Magazine, "Eartha Kitt," August 4, 1952; p. 65: Wellesley Rowing Crews in 1950 © Getty Images; p. 66: © Popperfoto/Getty Images; p. 67: © Condé Nast Archive/CORBIS; pp. 68–69: Jorie Butler Kent in 1982 © Getty Images; p. 70: © Maison Kitsuné HQ; p. 71: © Time & Life Pictures/Getty Images. Caption credit: LIFE Magazine, "Male Designs on Women: Ladies Shop for Selves in a Man's Store," April 5, 1954; pp. 72–73: Patsy Pulitzer in 1955 © Getty Images. Caption credit: Once Upon a Time by Slim Aarons; p. 74: Princess Caroline of Monaco © Richard Melloul/Sygma/CORBIS; p. 75: Smith College students in 1948 © Time & Life Pictures/Getty Images; pp. 76–77: Sarah Lawrence field hockey players in 1948 © Time & Life Pictures/Getty Images; pp. 78–79: Girls of Foxcroft School in 1960 © Getty Images; p. 81: © Condé Nast Archive/CORBIS; p. 82: Female pilot in 1943 © Time & Life Pictures/Getty Images; p. 83: Hoyningen-Huené / Vogue / Condé Nast Archive. Copyright © Condé Nast. Caption credit: The New York Times, T Magazine, "What's a Girl to Do When a Battle Lands in Her Lap" by Janine Di Giovanni, October 21, 2007; pp. 84–85: Osa Johnson courtesy of the Martin and Osa Johnson Safari Museum; p. 86: Ginger Rogers in 1942 © Time & Life Pictures/Getty Images; p. 87: Photo © Gregory White Photography; pp. 88–89: Miss E Foley and Miss L Ball on their motorcycles in 1929 © Getty Images; p. 90: Bette Davis in 1933 © Getty Images; p. 91: Esther Allen in 1948 © Time & Life Pictures/Getty Images; pp. 92–93: Steve and Neile McQueen in 1963 © Time & Life Pictures/Getty Images. Caption credit: NOWNESS, "Love in the Fast Lane: Neile Adams on Life with Steve McQueen"; p. 94: Amelia Earhart in 1929 © CORBIS; p. 95: © Ed Eckstein/CORBIS; p. 97: Julie Delpy in 1991 © Marianne Rosenstiehl/Sygma/Corbis; p. 98: Lauren Hutton in 1974 © Getty Images; p. 99: Ali MacGraw in 1971 by William Claxton /Courtesy Demont Photo Management; pp. 100–101: Susan Ford in 1976 Courtesy Gerald R. Ford Presidential Library; p. 102: Katharine Ross in 1969 © Photoshot/Getty Images; p. 103: May Britt in 1960 © Getty Images; p. 104: Patti McGee in 1965 © Time & Life Pictures/Getty Images; p. 105: Venice Beach roller skaters in 1983 © Getty Images; p. 106: Photo © Paul Wetherell/Courtesy of Twin magazine, creative direction Becky Smith, styling Celestine Cooney; p. 107: © David Seymour/Magnum Photos; pp. 108–9: Mariel Hemingway in 1976 © Tony Korody/Sygma/Corbis. Caption credit: Finding My Balance: A Memoir by Mariel Hemingway; p. 110: Teenagers in a Corvette in 1971 © Photo Media/ClassicStock/Corbis; p. 111: Françoise Hardy in 1963 © Pierre Fournier/Sygma/Corbis; pp. 112–13: Tatum O'Neal and Kristy McNichol in 1980 © Bettmann/CORBIS; p. 115: Hoyningen-Huené / Vanity Fair / Condé Nast Archive. Copyright © Condé Nast; p. 116: © Myriam Lutz; p. 117: Marina Muñoz © Sebastian Kim. Caption credit: Q&A with Marina Muñoz on tomboystyle.blogspot.com; pp. 118–19: Tilda Swinton in 1995 courtesy of Hugo Glendinning. Caption credit: W magazine, "Planet Tilda," by Diane Solway, August 2011; pp. 120–21: © Mark Borthwick; p. 122: © Norman Parkinson Ltd/Courtesy Norman Parkinson Archive; p. 123: Nicki Bluhm by Noa Azoulay-Sclater; pp. 124–25: Brigitte Bardot in 1977 © Leonard de Raemy/Sygma/Corbis.

acknowledgments

To my parents, for being my backbone and encouraging me to aim high.

To my older brother for letting me tag along every summer.

To the wonderful people who generously advised me along the way: Alexandra Malloy, Kingsley Woolworth, Rebecca DiLiberto, Elisabeth Weed, and Stephanie Sun.

To the Rizzoli team: Charles Miers, Anthony Petrillose, Aoife Wasser, Karen Broderick, Jennifer Pastore, Katelyn MacKenzie, Pam Sommers, and Jessica Napp.

To Julie Di Filippo, for guiding this project from day one and challenging me to see beyond my periphery. You're a sophisticate, an adventuress, and a damn fine editor.

First published in the United States of America in 2012 by
Rizzoli International Publications, Inc.
300 Park Avenue South
New York, NY 10010
www.rizzoliusa.com

2014 2015 2016 / 10 9 8 7 6 5 4 3

Designed by Aoife Wasser

ISBN-13: 978-0-8478-3842-4
Library of Congress Catalog Control Number:
2011941642

Printed in China

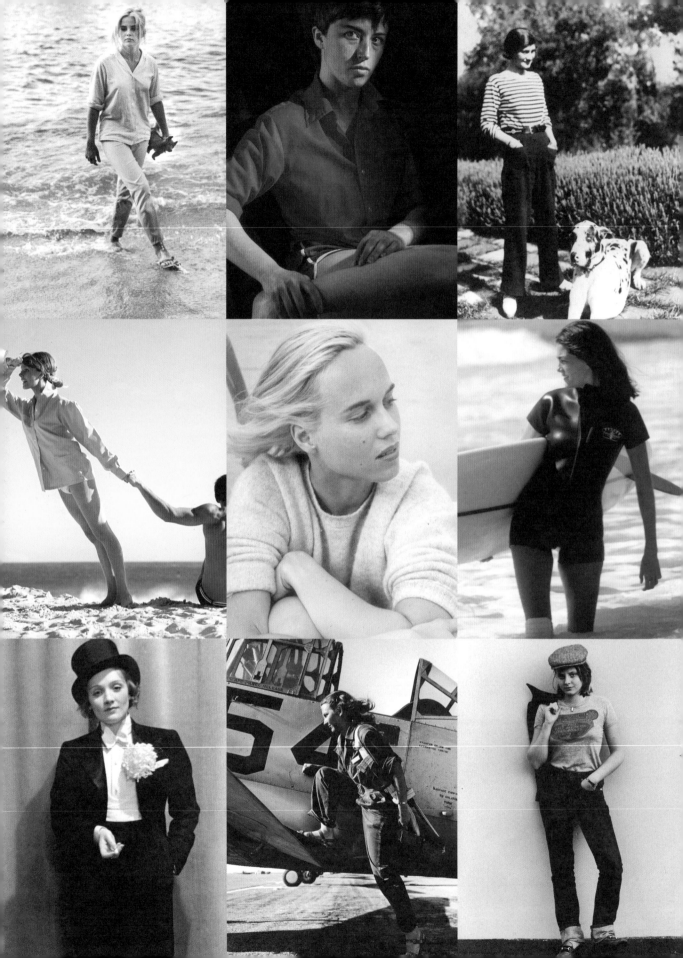